The Golden Age of Watercolours

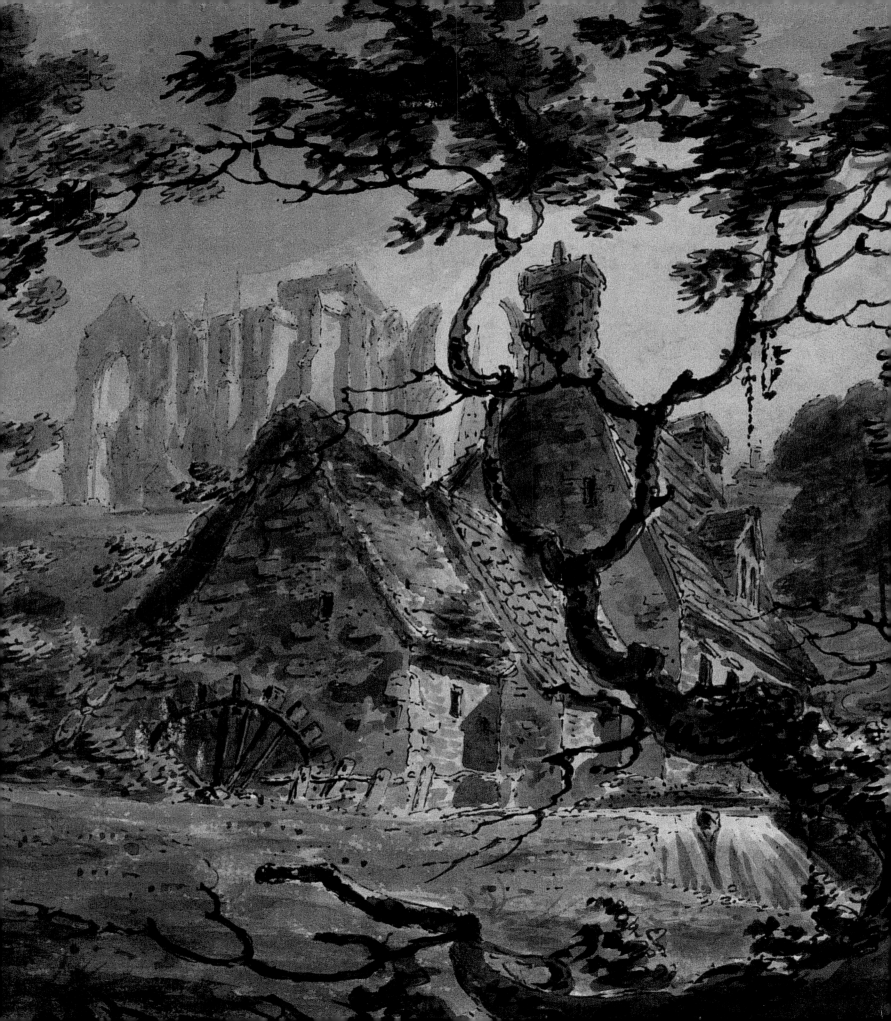

The Golden Age of Watercolours

Eric Shanes

MERRELL

In Memory of Evelyn Joll, mentor and friend

First published in 2001 by
Merrell Publishers Limited
42 Southwark Street
London SE1 1UN

Text © Eric Shanes
Illustrations © Sir Nicholas Bacon
All rights reserved.

This book has been published to accompany the
exhibition
The Golden Age of Watercolours: The Hickman Bacon Collection
being held at

Dulwich Picture Gallery
Gallery Road
London SE21 7AO
19 September 2001 – 6 January 2002

British Library Cataloguing-in-Publication Data
Shanes, Eric, 1944–
The golden age of watercolours : the Hickman Bacon
collection
1.Bacon, Sir Hickman – Art collection 2.Watercolor
painting, English 3.Watercolor painting, French
4.Watercolor painting – 19th century – England
5.Watercolor painting – 19th century – France
I.Title II.Dulwich Picture Gallery
759.2

ISBN 1 85894 146 6 hardback
ISBN 1 85894 147 4 paperback

Distributed in the USA and Canada by Rizzoli
International Publications, Inc.
through St Martin's Press, 175 Fifth Avenue, New York,
New York 10010

Produced by Merrell Publishers Limited
Designed by Tim Harvey
Edited by Sarah Kane

Printed and bound in Italy

Front jacket/cover: John Sell Cotman, *A Figure in a Boat on
a River*, 1830s (detail; see cat. 54)
Back jacket/cover: Peter de Wint, *Clee Hills, Shropshire*,
c. 1845 (see cat. 65)
Frontispiece: J.M.W. Turner, *Malmesbury Abbey*, c. 1791
(detail; see cat. 13)

The exhibition has been supported by

in association with

Contents

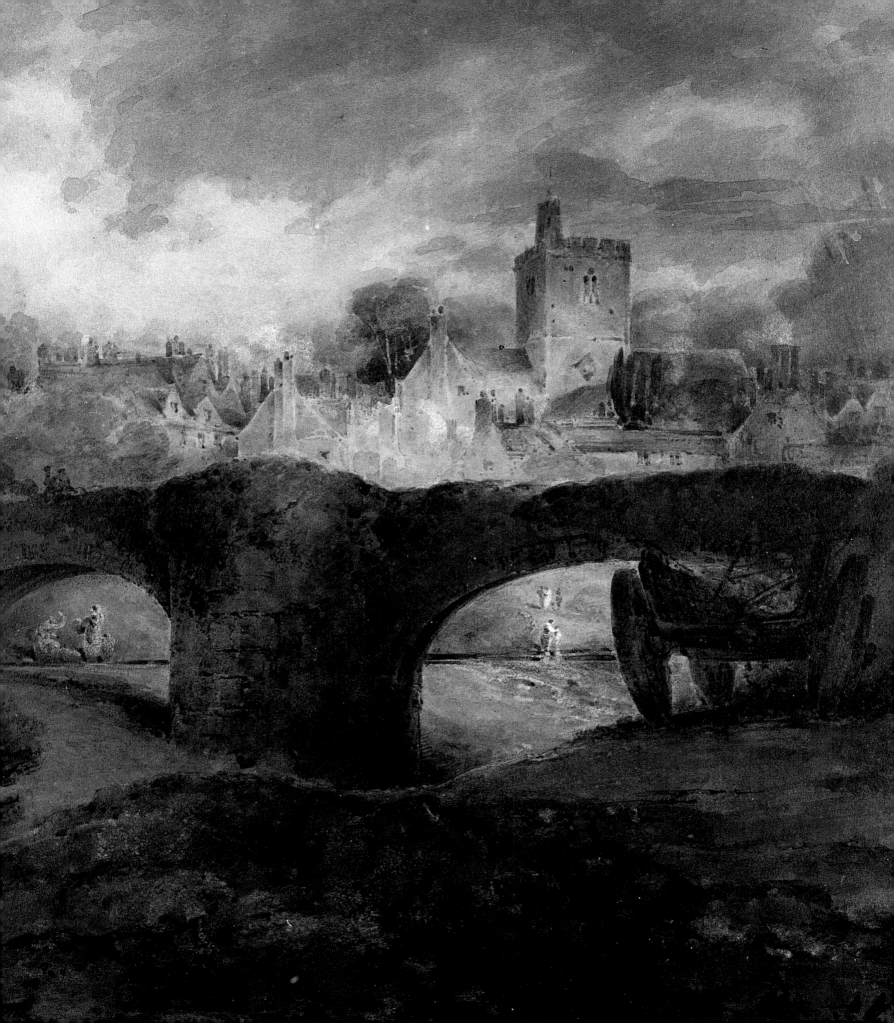

Foreword

The idea of an exhibition of the Hickman Bacon collection was first conceived some years ago. This led to a show in Japan in 1990 of some 100 works on paper. During their period in Bacon ownership the individual drawings have been exhibited widely but since 1948 never collectively. Historically, experts have pored over them, usually asking to exhibit one or two prime examples of their particular interest. However, seldom was it possible to reflect the enormous breadth of Hicky's unerring eye. He collected at a time when works of this type on paper were unfashionable. The fact that his brother Tommy formed a collection of similar taste (now at the Fitzwilliam Museum, Cambridge) was even more remarkable. It was perhaps fortunate that they did not compete for the same drawings.

We do hope that these examples of Hicky's taste will excite a similar response as the Great Watercolour Show did at the Royal Academy some years ago. The family have always taken a serious view to works being shown freely throughout the country to encourage an interest in the rich heritage of nineteenth-century watercolours. Our thanks go to the museums and directors who have made this possible. It is certain that without the enthusiasm of Eric Shanes, Andrew and Christie Wyld and Desmond Shawe-Taylor, this exhibition would not have got off the ground. Thus we are delighted to share a wonderful set of English watercolours that, if nothing else, shows the quintessential Englishness of my great-uncle Hicky.

SIR NICHOLAS BACON

Director's Foreword

The Hickman Bacon collection is without doubt the most important collection of English water-colours in private hands. This exhibition is the first opportunity for the British public since 1948, and for Americans ever, to see the best of this extraordinary collection as a group. The collection not only provides a near complete survey of the great age of landscape watercolours in Britain; it also has the special charm, quirkiness and coherence that reflect the enthusiasm of a single man, Sir Hickman Bacon. There is a special appropriateness in showing this collection at Dulwich Picture Gallery and at the Yale Center for British Art in New Haven, both of which house collections that offer at once a balanced survey of a particular period of art and at the same time the stamp of an individual collector's flair and taste.

Our first and greatest debt of thanks goes to Sir Nicholas and Lady Bacon, who have shown such enthusiasm in sharing their collection with the widest possible public and who have helped with every practical aspect of mounting this exhibition. We are also most grateful to Eric Shanes, the insti-gator and curator of the exhibition, and author of the catalogue. This exhibition is a collaboration between Dulwich and the Yale Center for British Art at New Haven, Connecticut; it has been a great pleasure and privilege to work with Patrick McCaughey and his colleagues, in particular Dr Scott Wilcox, the Curator of Prints and Drawings. We are also most grateful to Brian Allen and the staff of the Mellon Centre for British Art in London.

This exhibition has been most generously supported by Agnew's in association with W/S Fine Art. We are most grateful to Andrew and Christie Wyld for coming to us with this sponsorship and for arranging on our behalf the mounting and framing of the works on show. We are also greatly indebted to Rathbone's, and to Christie's for their generous sponsorship of the exhibition and for their help in securing government indemnity for the works; in particular we should like to thank Noël Annesley, Deputy Chairman of Christie's and Trustee of the Gallery, for all his help and Anthony Brown for providing valuations free of charge.

Eric Shanes has been assisted in his research for the catalogue by many distinguished fellow scholars. We should in particular like to join him in thanking the late Evelyn Joll, to whom the cata-logue is dedicated and who shared his immense expertise with absolute openness and generosity, as

always. We are also most grateful to Peter Bower, who has proved an invaluable source of advice, and to many other scholars, in particular David Hill, Anne Lyles, Dr Cecilia Powell, Kim Sloan, Susan Sloman, Ian Warrell, Henry Wemyss and Andrew Wilton. We should also like to join Eric Shanes in thanking Mick Duff, Janet Woodard and Jacky Darville for their help and support.

We have been very fortunate to have found in Merrell Publishers an ideal partner on this project; we would like to thank Hugh Merrell and his colleagues, and in particular Julian Honer and Matt Hervey, for producing such a handsome catalogue with such professionalism.

I am finally most grateful to my colleagues here at Dulwich Picture Gallery for their dedication and commitment to this project; in particular I should like to single out the contribution of Ian Dejardin, the Curator, and Victoria Norton, the Exhibitions Officer.

DESMOND SHAWE-TAYLOR

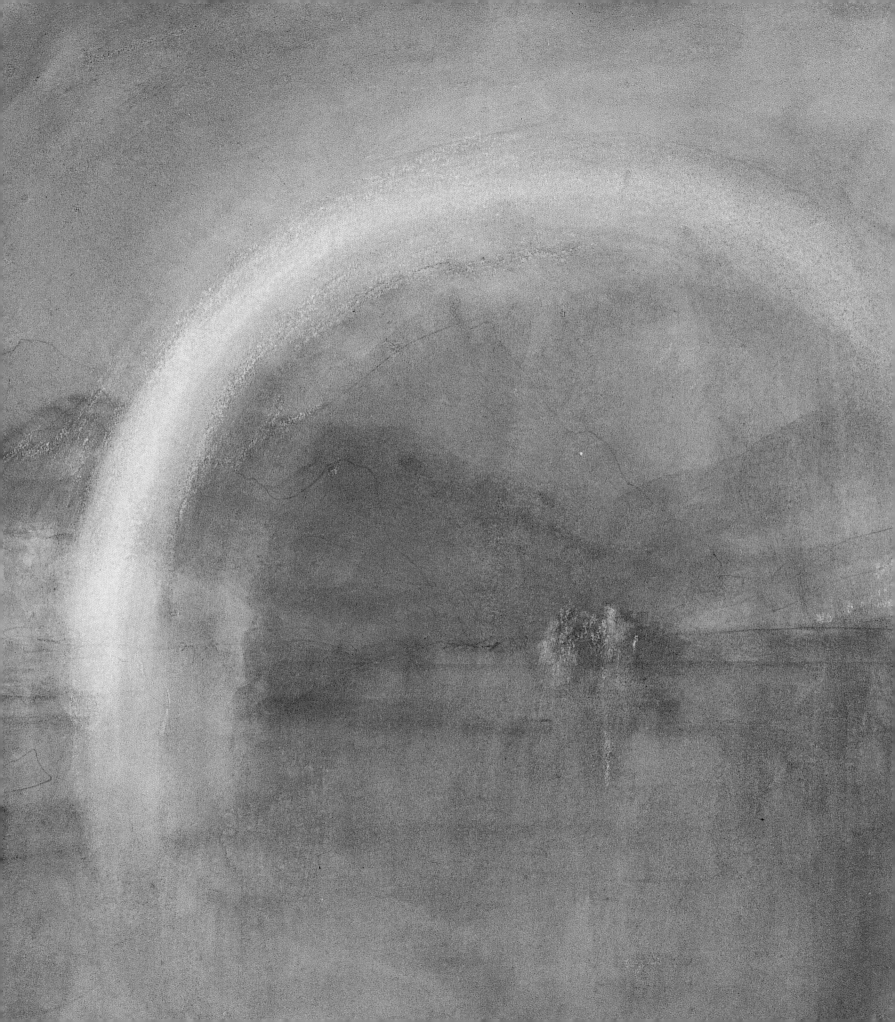

The Golden Age of Watercolours

THE HICKMAN BACON COLLECTION

ERIC SHANES

J.M.W. Turner, *Rainbow over a Swiss Lake, possibly the Lauerzer See*, c. 1844 (detail; see cat. 27)

Since its creation in the early years of the twentieth century, the Hickman Bacon collection of over 400 British watercolours and other drawings has generally been recognized as the leading private holding of such works anywhere. As such, it reflects the taste and unusual visual acumen of the man who originally assembled them.

Sir Hickman Beckett Bacon was born in 1855. On the death of his father in 1872 he inherited the titles of 11th Baronet of Redgrave and 12th Baronet of Mildenhall. The Baronetcy of Redgrave was the first baronetcy ever granted, having been conferred upon Sir Nicholas Bacon by King James I in 1611. Sir Nicholas was the son of a lawyer of the same name, who came from Redgrave in Suffolk and who had risen to the positions of Keeper of the Privy Seal and Lord Chancellor of England under Queen Elizabeth I. Because the Sir Nicholas ennobled by James I was the first baronet ever to be created, he and all subsequent holders of the title have thereafter been known as the Premier Baronets of England.

Among the subsequent outstanding members of the Bacon family were the first English amateur painter of note, Nathaniel Bacon (1585–1627), and the early American settler of the same name (1647–1676), who rebelled against British government; his burning of Jamestown, Virginia, is known in American history as 'Bacon's Rebellion'. The baronetcies of Redgrave and of Mildenhall came together in 1755 when Richard, the 8th Baronet of Mildenhall in Suffolk, also succeeded to the title of 7th Baronet of Redgrave.

Sir Hickman Bacon was educated at Eton. After serving in the Grenadier Guards as a lieutenant he settled at Thonock in Lincolnshire, where he lived in a large mansion he had inherited (fig. 1). In early life he suffered from ill health, but several sojourns in Madeira proved highly beneficial, and thereafter his general health improved. Although he had a passing affair with an Austrian countess, he remained a bachelor for the rest of his life. He had an excellent business sense and, having inherited a huge fortune from an aunt in 1915, he became very active in the London property market, serving as Chairman of the Colville Estate Company for over thirty years.

Sir Hickman Bacon not only worked hard on his own behalf; throughout his life he also threw himself into public service. Thus for many years he worked as an Alderman on Lindsey County

Council, a body he presided over as Chairman between 1914 and 1924, while in 1887 he became High Sheriff of Lincolnshire. Being something of an authority on water pollution and navigation rights, he served on the boards of various agencies concerned with waterways. Additionally he sat on the governing bodies of various schools, hospitals, youth organizations and charities, and often became Chairman of those groups. He encouraged the creation of parks in Lincolnshire, and even offered to fund an arboretum in Gainsborough, although sadly that offer was refused. As a devout Christian Sir Hickman naturally took an active interest in Church affairs, while in the political sphere he was unusually broad-minded, not only proving friendly with many prominent Liberals and Conservatives such as Winston Churchill, but also with socialists such as Beatrice and Sidney Webb.

A further indication of his broad-mindedness was his support of his local Co-operative Society and of the Working Men's Institute, socialist organizations that attempted to improve the lot of ordinary working people through financial sharing and education respectively. In 1896 Sir Hickman was even made an honorary member of the Boilermakers and Iron and Steel Ship Builders Society in recognition of his services to the Lincolnshire shipbuilding industry. In every way Sir Hickman Bacon typified the English aristocracy at its most cultured, worldly and philanthropic. When he died at the ripe age of ninety in 1945, his lengthy obituary in one leading Lincolnshire newspaper aptly ended by stating that "Few men had led such an active public life, the value of which will become more patent as the years pass on".

Yet the baronet was not only a man of duty; equally, he enjoyed his pleasures. He financially supported Lincolnshire football, cricket and golf clubs, and while still young joined the Royal Yacht Squadron. With the advent of the automobile he transferred his loyalty to motor cars (fig. 2), racing

at eighty miles an hour on the Brooklands race track and thinking up devices like a brass carburettor with which to enhance performance. Eventually his knowledge of the mechanical side of motoring led to his being elected a member of the Society of Automobile Engineers, and he was also one of the earliest members of the Royal Automobile Club, as well as of the Brooklands Racing Club, for which organization he became a Steward. And he continued to drive almost up until his death, puttering around the narrow Lincolnshire lanes in his battered, twenty-year-old Austin saloon car.

Sir Hickman Bacon was elected to the Society of Antiquaries at the age of just twenty-three. He collected fabrics, wall-hangings, ceramics and Japanese prints, a group of which he gave to the Japanese government early in the last century. Yet his private pleasure that has ultimately proved of most lasting value was his collecting of English watercolours. The baronet appears to have begun avidly acquiring such works only after about 1895, when he was in his forties, and his collection was fairly complete by 1914, although he added further works to it intermittently after that date. Eventually there were over 400 watercolours in the collection, and these complemented the various fine oil paintings that he had inherited, including works by Dutch, Flemish and German painters (one of which, by Albrecht Dürer, was sold to the National Gallery, London, just a few years ago by the present owner of the Bacon collection). British oils included works by Richard Wilson, John Sell Cotman and John Constable. Because Sir Hickman Bacon was without issue, after his death in 1945 both his two baronetcies and his watercolour collection passed to his nephew, Sir Edmund Castell Bacon (1903–1982), and thence to Sir Edmund's son, Sir Nicholas Bacon (born 1953), the present owner.

An idea of the collector's personality in later life, and his concern for his drawings, can be gleaned from a letter written in September 1937 to her sister Dorothy by an art historian, Margaret Pilkington, who was organizing an exhibition of works by John Robert Cozens and John Sell Cotman at the Whitworth Art Gallery, Manchester. She went to see Sir Hickman at Thonock and recalled:

We drove through to his gates and then through more than a mile of parkland (he has 9000 acres) before we got to Sir Hickman Bacon's house, a great big house of Victorian style covered with ivy. The upper stories looked empty. We could not at first make up our minds which of the two doorways was the front door. But I actually chose the right one and rang the bell and waited for what seemed a long time … . Eventually a tall, frail old gentleman in light tweeds came into the hall, saw me and opened the door. He looked at me rather severely and said, "You have come earlier than you said you would". I explained that not being sure of the route and distance I had allowed extra time so as not to be late for the appointment. He then said "I suppose you know that I don't like lending my pictures?". I said that his letter had made that clear … . He then took me upstairs. He is a beautiful old man, very distinguished looking, with a white beard and a thin refined face – rather austere but full of life and character. His hands are also very sensitive … . We went up the staircase hung with pictures and into a large disused bedroom. Every chair and table in that room and the bed itself was covered with packets of old letters tied into bundles with tape – I imagine they referred to past loans and purchases. Under every piece of furniture

and round the room were piles of empty frames. He opened a huge wardrobe and inside it were piles of mounted drawings. There for an hour I had a very severe test of my patience and tact. He would bring out a drawing and push it back before I had seen it properly. He eventually decided that he would show me some of the Cozens drawings (the wardrobe was full of all sorts of old masters, Turner, Girtin, Wilson etc. etc.). This he did and then said I mustn't have the big ones because it would be safer to have the smaller ones. I had a mind to the possibility of getting some Cotman drawings, so chose out three of the smaller Cozens – explaining in each case the reason for my choice. This seemed to melt him a little … . He decided finally that we might have some [Cotmans] provided that he could find the frames belonging to them. Then for a painfully long time he insisted on searching through the piles of frames, obviously a task too much for him but my offers of help were refused … . But we had one further amicable tussle. He produced a very fine drawing of a bridge in Durham [by Cotman, cat. 44] which I pounced on at once. He said that I couldn't have that one as it had just been to Leeds – I said but surely the Leeds exhibition was of paintings of Yorkshire scenery? He agreed that this was so and that it might have been his Richmond drawing that went to it. So might we have it? said I – "No" says he, "I know it was lent lately and it looks to me a little faded". I left the matter and we looked at different drawings. He put it away, I asked to look at it again, and I kept on putting it out on a chair and saying if he would only agree to it, that this was the one I wanted. And in the end I got it and four others. By this time the old gentleman was quite friendly tho' naturally rather exhausted and I was rather relieved when he decided that the matter might rest, tho' I longed to see more of the contents of that cupboard. He is 82, so an hour and a half of that sort of thing was more than enough.

[Document in the Bacon family archives]

Despite the clutter in which Sir Hickman Bacon kept his drawings, it is evident from this account that he cared passionately about their condition. His concern is reflected in the fact that most of his watercolours remain in an excellent state. Only a few works by John Robert Cozens, John Crome and Thomas Girtin have suffered the ravages of time, and that damage mostly resulted from their being temporarily stored in the basement of the Tate Gallery when it was flooded in 1928.

Sir Hickman Bacon had unusual tastes for his time. Thus the collection is especially strong in the type of late, ethereal Turner watercolour that became widely popular only with the advent of abstract painting in the 1940s and 1950s. Similarly, although the supreme glory of the collection is arguably its group of watercolours by John Sell Cotman, when Sir Hickman began purchasing them long before the First World War, Cotman had only just emerged from total obscurity (indeed, his popularity would begin to grow only after 1922, when his work was accorded its first major showing at the Tate Gallery in London). Naturally, this comparative lack of popularity was reflected in the small amounts of money that Sir Hickman Bacon spent on his drawings; even though the pound then bought far more than it does today, the baronet expended comparatively little to build his collection. Thus Cotman's *Brecknock* (cat. 37) was purchased in 1900 from the Palser Gallery for just £80, while the same artist's *Scene in the Black Country* (cat. 39) cost the baronet merely half that sum

in the same year. Even in 1914 (by which time Cotman's prices had generally risen) Bacon only paid £52 10s. for *A Screen, Norwich Cathedral* (cat. 46). But Cotman's prices were high in comparison with those of John Robert Cozens; an idea of how little that fine painter was generally valued at the time can be gleaned from the fact that, prior to 1910, Sir Hickman spent little over £20 on average for key works by the watercolourist. Even John Crome's outstanding *The Blasted Oak* (cat. 36) cost Sir Hickman just £63 in 1908, while for what is not only arguably the best work by Girtin in his collection but one of the finest Girtins anywhere (the *View of the Gate of St Denis, taken from the suburbs of c. 1802*, cat. 12) the collector expended just £110. Occasionally Sir Hickman did have to pay handsomely, as in 1909 when he gave Agnew's £200 for Turner's *Mount Pilatus from across the Lake of Lucerne* (cat. 25). Yet on the whole his expenditure was much more modest, for he did not need to lay out large sums. This was because he possessed the rare talent of being able to discern the merits of artists who were not yet in vogue, or aspects of their œuvre that were still unfashionable.

Because Sir Hickman Bacon's taste was highly focused there are inevitable omissions from the collection. Thus it contains no drawings by Richard Wilson or by John Constable, nor are there any works by William Blake or Samuel Palmer, or by acknowledged masters of the English topographical tradition such as Thomas and Paul Sandby, Francis Towne and Michael Angelo Rooker. The absence of Blake and Palmer possibly reflects the fact that Hickman Bacon did not care for visionary imagery, while the lack of works by the topographical watercolourists perhaps demonstrates that his taste was mainly for evanescent and impressionistic effects, rather than for the specifics of landscape. As a result, with the exception of a few very early Turner drawings and the same artist's late *The Sarner See, Evening* (cat. 26), one looks in vain amid the forty-odd Turners in the collection for the type of highly finished topographical watercolour that had proved a mainstay of the painter's career. Yet if there are

Fig. 2. Sir Hickman Bacon at the wheel of a car outside the Wolseley factory in Adderley Park, Birmingham, with Herbert Austin standing on the left.

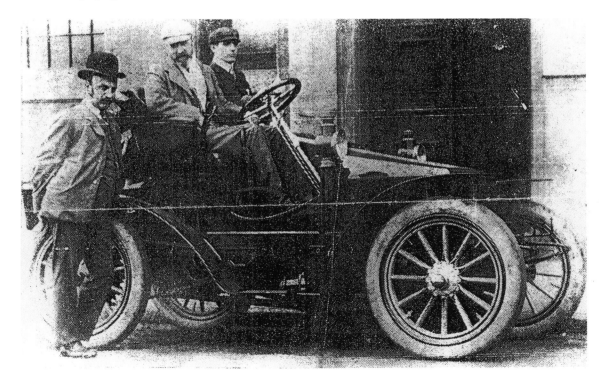

undeniable gaps in the collection, there are also many strengths, and it seems valid to claim that with three major artists at least – John Robert Cozens, Thomas Girtin and John Sell Cotman – the Hickman Bacon collection represents the range and importance of those masters in fairly full measure.

The magnificent group of watercolours by John Robert Cozens (cat. 1–6) shows the growing response to space and light that the artist brought to landscape painting as a result of his exposure to the Alps and Italy. The Girtins (cat. 7–11) are mostly of outstanding quality, and make clear how widely this gifted artist expanded landscape painting during his tragically short career. The Cotmans (cat. 37–55) demonstrate the artist's varied styles, each of which he made uniquely his own.

The Turners in the collection (cat. 13–33) reveal a number of important facets of the artist's genius in watercolour. Both Joshua Cristall and John Crome (cat. 34–36) are represented by drawings of unusual quality. Works by David Cox and Peter de Wint (cat. 57–65) manifest the growing liberty of expression that watercolour permitted as the nineteenth century progressed, a freedom that anticipated French Impressionism. Similarly, watercolours by Louis Francia, Richard Parkes Bonington and Thomas Shotter Boys (cat. 66–71) make evident the direct links that existed between English and Continental landscape art, in addition to the growing British interest in Continental subject-matter. Drawings by John Frederick Lewis (cat. 72–75) demonstrate Sir Hickman Bacon's partiality for virtuosic displays of draughtsmanship. The landscapes of William James Müller (cat. 76–80) were particularly favoured by the collector, which might seem surprising, given Müller's fondness for topographical detail, but perhaps it was the artist's flamboyant draughtsmanship and crisp responses that appealed to him. And watercolours by Joseph Severn and Albert Goodwin (cat. 81–82) demonstrate that he equally appreciated comparatively recent work in watercolour.

The Hickman Bacon collection represents English watercolour painting at its finest, even if a number of major and minor figures of the school are not included (and it must be remembered that the works being displayed here constitute less than a quarter of the entire holding). The collection can usefully serve to typify those great collections of British watercolours that proliferated in the nineteenth century, no other examples of which still survive in private hands. It is entirely to the credit of its present owner that the collection has been kept together, both as a tribute to the man who founded it, and as a demonstration of that discerning aristocrat's commitment to acquiring works of art not because they were in fashion, or because they might grow in financial value, but simply because he prized them visually. In our own day, when the accumulation of works of art has frequently become a means of enhancing social status and/or hedging against inflation, Sir Hickman Bacon's quietly passionate collecting skills still seem worthy of celebration.

John Sell Cotman, *Trees near the Greta River*, c. 1805 (detail; see cat. 42)

JOHN ROBERT COZENS, 1752–1797

J.R. Cozens was born in London, the son of the artist Alexander Cozens, with whom he studied. He first exhibited in 1767. Two trips to Italy followed, the first between 1776 and 1779 in the company of a leading collector, Sir Richard Payne Knight, and the second in 1782–83 with William Beckford, the eccentric author, builder, collector, libertarian and slave owner who was a friend and patron of his father. In later life J.R. Cozens suffered from insanity, and he died in the care of the physician, amateur artist and collector Dr Thomas Monro, whose work is also represented in the Bacon collection.

J.R. Cozens proved an enormous influence on the following generation of English painters, especially Girtin, Turner and Constable (who called him "the greatest genius that ever touched landscape"). This influence derived from Cozens's skill in expressing an imaginative response to place, his ability to communicate the grandeur of landscape in ways that were unprecedented in watercolour, his penchant for inventive composition, and his tonal and colouristic control. All of these characteristics are especially well represented in the works by him in the Bacon collection.

I

JOHN ROBERT COZENS, 1752–1797

Valley of the Ober Hasli, Switzerland
c. 1776, pencil and watercolour, 34.2 × 27.3 cm (13½ × 10¾ in.)
Bacon Inventory Number: I/E/13

This drawing has traditionally been known as 'A View near Rome' but it depicts exactly the same towering prospect that Cozens represented in a slightly larger watercolour of the Ober Hasli Gorge (the upper valley of the River Aare) in Switzerland, a work now in the collection of Eton College (see Sloan 1986, p. 122). The larger design is more elaborate, containing as it does some men pulling a boat in the foreground, and a solitary large bird flying through the ravine, both of which establish the vast scale of the landscape. In the Eton drawing Cozens also omitted the trees above the gorge on the left, and pulled down the branches of the tree growing from behind the rock at the lower left, so as to enhance the immensity of the setting even further.

The present watercolour may have been made while Cozens was touring Switzerland with Richard Payne Knight in the summer of 1776, whereas the more detailed and calculatedly sublime Eton version was probably worked up at leisure when back in Britain. Both drawings certainly articulate Payne Knight's views on the fearfulness and majesty of awesome scenery.

Catalogue
Citations of literature in the text refer the reader to books listed in the Selected Bibliography on page 126–27.

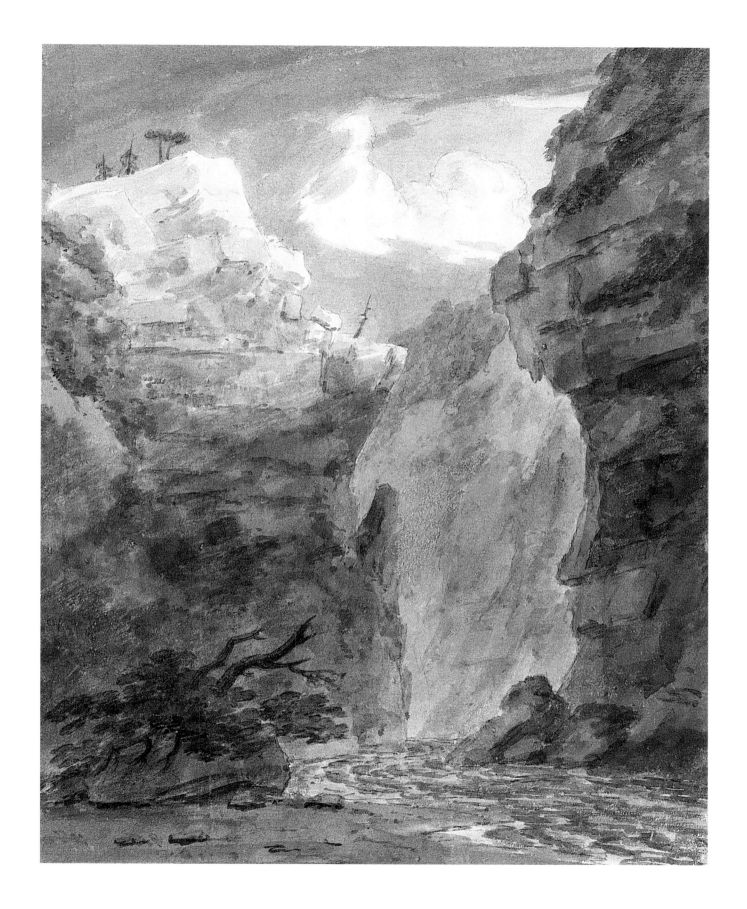

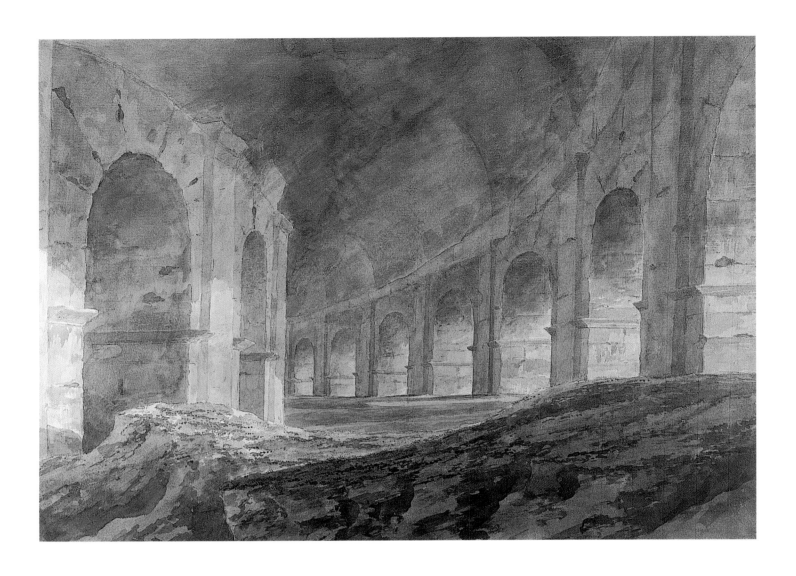

2

JOHN ROBERT COZENS, 1752–1797

Interior of the Lower Ambulatory of the Colosseum, Rome
signed and dated 1778 on the artist's mount, watercolour, 45.2 × 61.7 cm (17¾ × 24¼ in.)
Bacon Inventory Number: I/E/6

This tautly structured and atmospheric design was almost certainly made during Cozens's first trip to
Italy. Other depictions by Cozens of more subterranean parts of the Colosseum have been interpreted
as alluding to the once murderous uses of the building, but here the artist seemed content to allow
the mouldering ruin to make its own comment upon the desolate associations of history.

3

JOHN ROBERT COZENS, 1752–1797

Lake Nemi
signed and dated 1780 on the artist's mount at the lower left, pencil and watercolour, 41.4 × 63.5 cm (16¼ × 25 in.)
Bacon Inventory Number: I/E/3

Lake Nemi is located in the Alban Hills about twenty kilometres south-east of Rome. The date appended to this particular portrayal demonstrates that the work was developed back in London as one of a number of views of the lake from various angles. Here we look across it to the west, in summer evening light, with the sun setting in the north-west beyond the right-hand edge of the image. The village of Genzano stands above the far bank of the lake, with the Anzio promontory discernible far beyond it. The dark tones in the foreground heighten the sense of distance by means of their contrast; the diagonal running to the lower left greatly strengthens the composition. The few figures add the only note of animation to the entire scene, while equally establishing the immensity of the landscape.

4

JOHN ROBERT COZENS, 1752–1797

In the Garden of the Colonna Palace, Rome
early 1780s?, watercolour, 26.2 × 36.1 cm (10¼ × 14¼ in.)
Bacon Inventory Number: I/E/10

This drawing was possibly made during Cozens's second visit to Italy in 1782–83 and it demonstrates the artist's fine eye for characterful corners of reality, his flair for unconventional compositional structures and his occasional penchant for a low-keyed but expressive naturalism. We look south-westwards in morning light, with the dome of the Church of the Santissima Nome di Maria in the distance on the right. To the left of it may just be discerned the top of Trajan's Column, capped by its statue of St Peter which displaced a likeness of the Roman emperor in 1588.

In the centre two men sit by huge blocks of masonry that are probably remains of the Roman Temple of Serapis that once stood on this site; in a typical eighteenth-century moralistic manner Cozens surely intended us to think that the idlers are not only enjoying the beauty of their surroundings but also ruminating upon former glories and their ultimate ruin.

5

JOHN ROBERT COZENS, 1752–1797

Florence from a Wood near the Cascine
c. 1783, watercolour, 26.2 × 36.8 cm (10¼ × 14½ in.)
Bacon Inventory Number: I/E/11

The depiction of light and complex tree forms in this dawn scene surely make it one of Cozens's finest works. The 'Cascine' of the title is a park that had been laid out earlier in the eighteenth century around the Grand Ducal dairy farms or *cascine*. In the distance may be seen the tower of the Palazzo del Bargello, to the right of which stands the higher tower of the Palazzo Vecchio, the town hall of Florence.

The design is based on a pencil drawing made on the spot on 21 September 1783 (Beckford sketchbook, Whitworth Art Gallery, Manchester), although Cozens moved the two distant towers slightly further apart when making the watercolour.

6

JOHN ROBERT COZENS, 1752–1797

Isola Bella, Lake Maggiore
1780s?, pencil and watercolour, unfinished, 49.3 × 67.3 cm (19¼ × 26½ in.)
Bacon Inventory Number: III/7

Although this drawing is clearly unfinished, its unusual composition and compelling spatial projection still make it one of Cozens's most original works.

The artist visited Lake Maggiore on his way back from Rome in 1783. On his return to London he produced a number of watercolours depicting it from different viewpoints; compositionally this is the most unconventional of them. We look westwards from just past the northern tip of the most manicured of the Borromean Islands. Clearly Cozens actually saw this vista from a boat, and thought the island would form a highly effective framing device, which it certainly does.

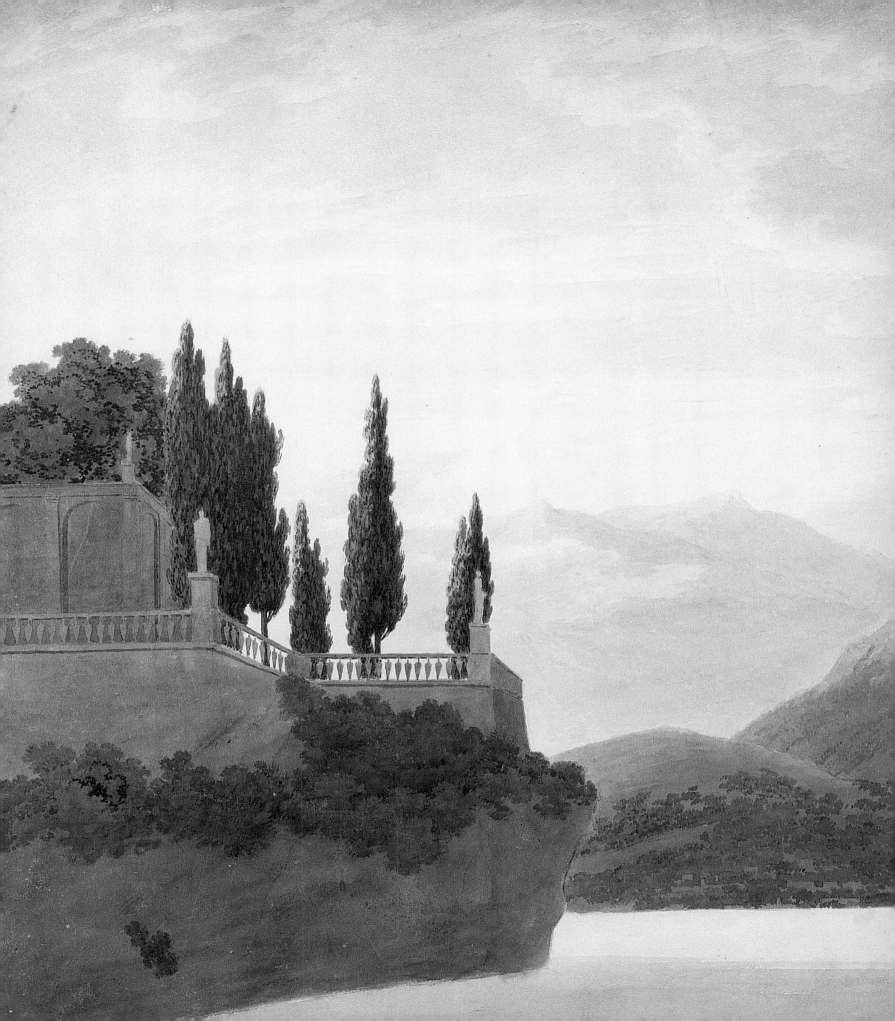

THOMAS GIRTIN, 1775–1802

Girtin was born in Southwark, the eldest son of a ropemaker. His father died when he was eight and his stepfather subsequently encouraged him to take up painting. Among his teachers was Edward Dayes, with whom he quarrelled. In 1792 Girtin may have first met Turner at the studio of the engraver John Raphael Smith, and they certainly worked together after 1794 in the 'Academy' of Dr Thomas Monro who employed both artists on winter evenings to copy works by Canaletto, Piranesi, Wilson, Malton, Hearne, Dayes and Morland, among others.

Girtin possibly toured Scotland in 1792, and he is known to have explored the Midlands in 1794, the south-east coast of England in 1795, and the North of England in 1796 and 1798 (when he also visited North Wales), as well as in 1799 and 1800. In 1799, along with Louis Thomas Francia and Robert Ker Porter, he founded a society known as 'The Brothers' whose aim was to promote the painting of historical subjects in watercolour; later this group was renamed the Sketching Society. In 1800 Girtin married, and in that same year began a large panorama of London, but by then his health was failing, and although he tried to improve his condition by moving to Paris in 1801, he was unsuccessful and died after returning to London. Turner always held Girtin in the highest regard, and stated flatteringly (if somewhat untruthfully) that had he lived "I would have starved".

During his tragically short career Girtin advanced the art of watercolour considerably, bringing to the medium a far greater expressiveness and technical range than it had hitherto enjoyed, along with an enhanced sense of atmosphere and spatial grandeur, qualities that influenced Turner.

7
THOMAS GIRTIN, 1775–1802

Windsor Castle from the Great Park
c. 1795, signed lower centre, pencil and watercolour, 20.3 × 26.7 cm (8 × 10½ in.)
Bacon Inventory Number: I/E/17

The copying of works by Canaletto at Dr Thomas Monro's 'Academy' after 1794 quickly led to a change in the pencil drawing techniques of both Girtin and Turner, for by creating lines terminating in emphatic dots they adopted a denotive process employed by the Italian master. Simultaneously, Turner's frequent use of warm underpaintings soon influenced Girtin. Both of these changes have a bearing on the possible date of this watercolour. A large number of dark-toned dots appear in the work, the yellow-ochre underpainting of which equally suggests that it was made around 1795. (Moreover, the lack of solidity in the castle further hints at such a date, for Girtin's greater awareness of architectural mass would only really begin to develop in 1796.) If this watercolour was made around 1795, then possibly it was inspired by a similar view of Windsor by Turner made at about the same time (collection HM The Queen, see Wilton 1979, variant of no. 122). Perhaps Turner influenced Girtin when on a joint painting expedition to Windsor Great Park.

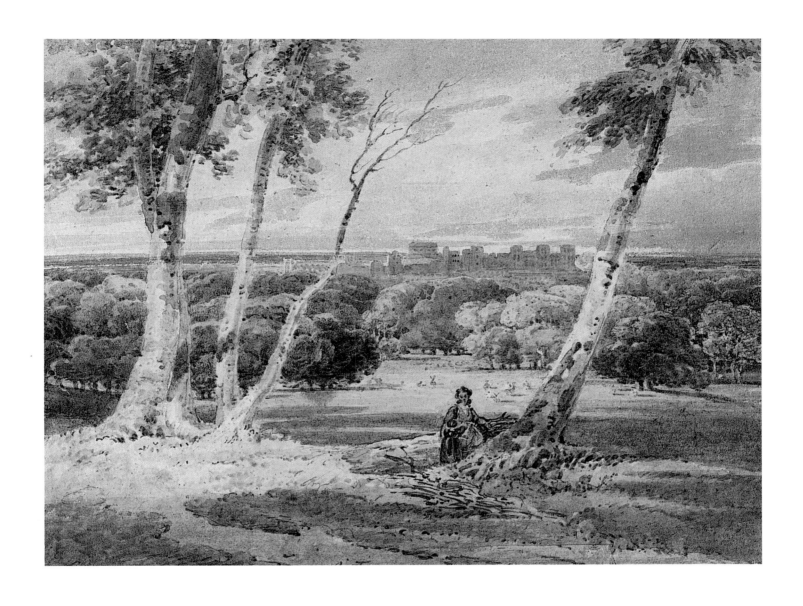

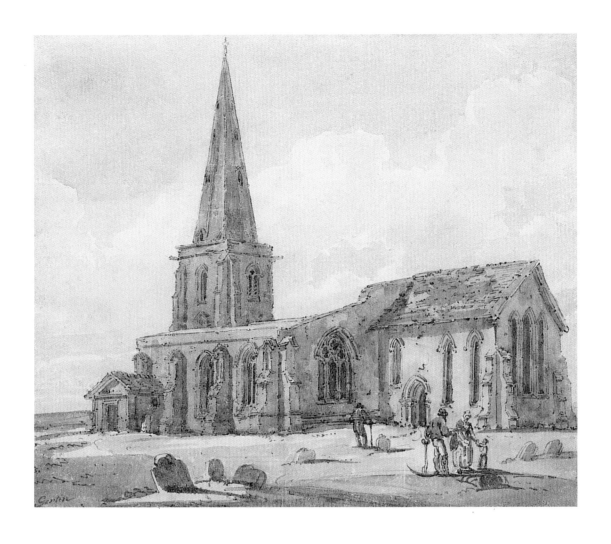

8

THOMAS GIRTIN, 1775–1802

A Country Church with Spire
late 1790s?, pen and brown ink with watercolour, 18.4 × 20 cm (7¼ × 7⅞ in.)
Bacon Inventory Number: I/E/18

The church depicted stands in what might be open heathland; it has not been identified, but Girtin was clearly in a moralizing mood when he portrayed it. In the foreground, before an old man leaning on a stick and hobbling towards a church door, a child peers into an open grave as its mother and a gravedigger look on. Such a reminder of ultimate things in connection with country churchyards was common in Girtin's day, being frequently encountered in painting and in poetry such as Gray's *Elegy* and Blair's *The Grave*.

The drawing of the building is very adroit, as is the balance of subtly differentiated warm and cool tones, which amply convey the warmth of the sunlight.

9

THOMAS GIRTIN, 1775–1802

A Mill in Essex

c. 1799, watercolour laid down on a wash mount, 43.2 × 60.3 cm (17 × 23¾ in.)
Bacon Inventory Number: I/E/15

This drawing was possibly exhibited at the Royal Academy in 1799 (no. 341) under the title given above. It may show a mill that stood at Stansted, and it could well have been inspired by a renowned oil painting of a mill then attributed to Rembrandt (National Gallery of Art, Washington, DC) that was on show in London during the first half of 1799.

On the path between the gates at the left a horse and a figure are just visible, having been partially washed or rubbed off. Clearly they originally played a vital compositional and energizing role in the image, so it seems unlikely that the artist was responsible for their effacement (and if he had wanted to obliterate them he would surely have made a better job of it). Perhaps they were removed by accident or because they were not appreciated by an early owner of the work, although it hardly seems likely that Hickman Bacon would have taken such a liberty.

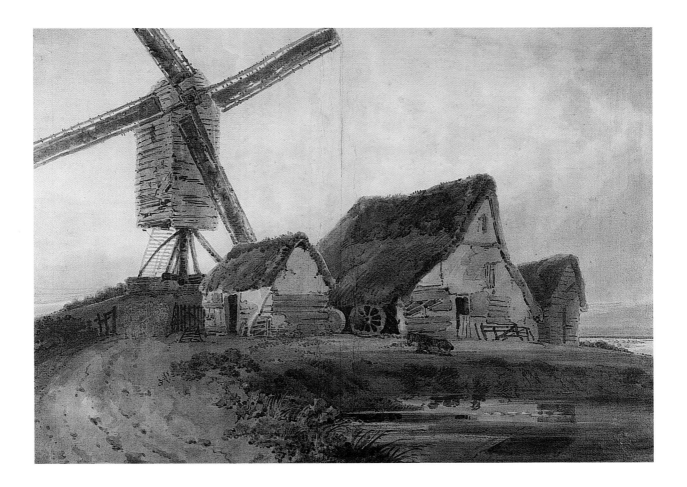

10

THOMAS GIRTIN, 1775–1802

Conwy Castle
signed and dated *Girtin 1800* at lower left, pencil and watercolour, 26.2 × 52.8 cm (10¼ × 20¾ in.)
Bacon Inventory Number: I/E/25

Girtin visited North Wales in the summer of 1798, and probably returned there during the early summer of 1800, when he might have stayed with Sir George Beaumont at Benarth near Conwy, along with John Sell Cotman and Joseph Farington. If Girtin had formed part of a sketching party organized by Beaumont, he might well have witnessed the artist he represented at work in the middle distance of this panorama. It is conceivable that the distant painter is Cotman, who made several views of Conwy Castle.

Conwy Castle is one of the most impressive medieval fortifications in Wales, and here we view it from the south-east in late afternoon light. Cleverly, Girtin placed a fairly horizontal bank of clouds above almost all of the ramparts on the left, and located a massive cloud above the castle keep, thereby subtly stressing the stronghold's dominance of the landscape. (In placing the large cloud where he did, Girtin was also turning to his advantage a defect in the paper, for, as Peter Bower has discerned, some of the upper edges of the clouds follow the exact shapes made by fairly deep original indentations in the gun cartridge paper used for the drawing.) The breadth of the vista, the serene light, and the representation of the near stretch of the River Conwy, are especially outstanding, particularly for an English watercolourist working in 1800.

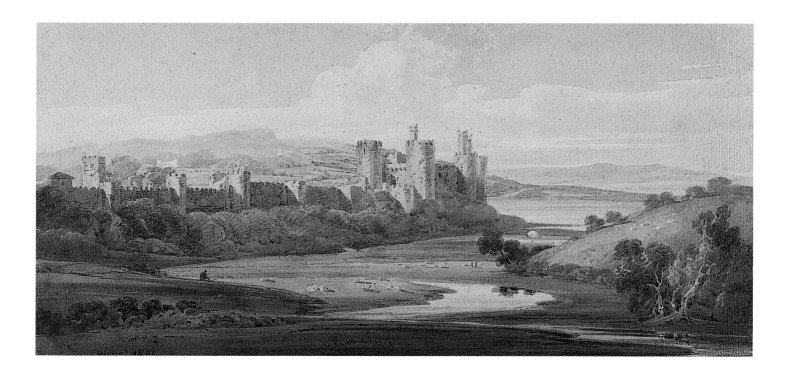

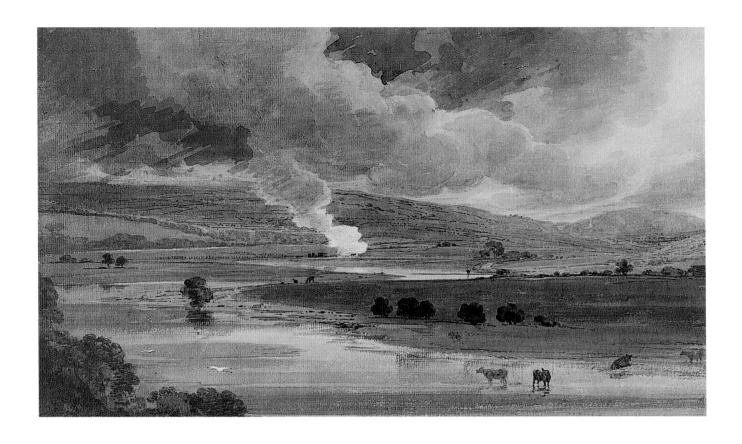

11

THOMAS GIRTIN, 1775–1802

The River Wharfe

c. 1800, watercolour, 31.7 × 52.8 cm (12½ × 20¾ in.)

Bacon Inventory Number: I/E/19

The linear sweep of the depiction of the river in cat. 10 completely fills this view of Wharfedale, as seen from near Otley, Yorkshire. Girtin toured the North of England in 1796, 1798, 1799 and 1800, and this watercolour was probably made on the last of those tours or shortly afterwards.

Although Girtin limited his colour range here – obviously to portray a typical English summer's day with accuracy – his use of a pale yellow-ochre underpainting, and his distribution of whites and soft blues, avoids any sense of colouristic monotony. His tendency to spread his dark tones through-out the entire extent of a landscape (rather than limit them to the foreground and thereby obtain a greater sense of spatial recession) is very much in evidence, but because the scene was drawn so firmly the necessary depth is still suggested. The smoke adds a vital dynamism to the landscape, for without it the vista would be far too static. Around the edges of the image a band of darker tone was once hidden from light by a frame; the reddish, lighter areas within it were probably caused by Girtin's use of indigo, which is notorious for discoloration and fading.

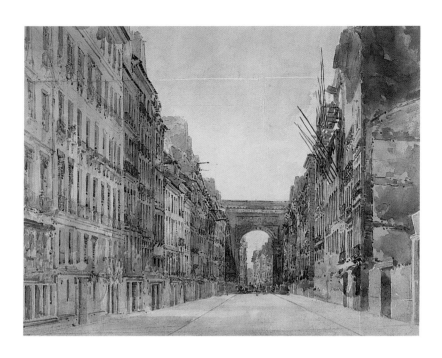

12

THOMAS GIRTIN, 1775–1802

View of the Gate of St Denis, taken from the suburbs

c. 1802, pencil and watercolour, 39.3 × 49.5 cm (15½ × 19½ in.)

Bacon Inventory Number: I/E/16

In November 1801 Girtin took advantage of the recent conclusion of peace with France to visit Paris, where he stayed for five months. This watercolour, which was probably made back in London, is one of the most memorable views he created of the city. The taut perspective of the street, plus the ruled lines across the bottom of it, suggest that the image may have been elaborated as a backdrop design for either the Covent Garden Theatre or for the playhouse in Drury Lane.

Girtin further used this view for a soft-ground etching of the rue St-Denis crowded with traffic. He drew the design on 29 September 1802, and it was subsequently aquatinted by F.C. Lewis for Girtin's *Twenty of the most Picturesque Views in Paris*. The print was published by the painter's brother, John, on 16 December 1802, five weeks after Thomas's untimely death on 9 November. As Girtin would surely have employed the title of that aquatint for the drawing as well, it is given above.

Traditionally, artists have placed their darkest tones in the foreground, and gradually lightened them towards the background, in order to project the maximum depth of space. However, Girtin often ignored that rule, and here a single dark tone defines both the distant gateway and several of the intervening buildings. However, the sense of space does not seem diminished, for the marked perspective establishes it firmly, while the delicate tones in the foreground intensify the luminosity of the near part of the street.

JOSEPH MALLORD WILLIAM TURNER, RA, 1775–1851

Turner was born in London, the son of a barber. As a result of the mental instability of his mother he was sent to stay with relatives outside London, where he probably received his schooling. He was admitted to the Royal Academy Schools in 1789, and in 1790 exhibited for the first time in the Royal Academy's Annual Exhibition. He supplemented his studies both by working with topographical landscape painters such as Thomas Malton Jr and, between 1794 and 1797, by adding watercolour washes to outlines drawn by Girtin during evenings spent at Dr Monro's 'Academy'. In 1793 Turner was awarded the Greater Silver Pallet of the Society of Arts for landscape painting. In 1796 he exhibited his first oil painting at the Royal Academy, while in the 1801 RA Exhibition he caused a sensation with one of his seascapes, a work that was thought to improve upon Dutch marine painting; this success contributed greatly to his election as a full Royal Academician in 1802 (he had been elected an Associate in 1799). In 1804 Turner opened his own gallery in London, but he continued to exhibit regularly at the Royal Academy throughout his life.

From 1791 onwards Turner made annual tours during the summer months in order to obtain material for his paintings and watercolours; by the end of his life he would have made more than fifty-five such journeys. Some of the more notable forays included trips to Scotland in 1801, to Switzerland in 1802, to Holland and Germany in 1817, to Italy in 1819–20 and 1828–29, across Europe from Denmark to Venice in 1833, to Venice again in 1840, and to Switzerland in 1836 and four times annually after 1841.

In 1807 Turner was elected the Royal Academy Professor of Perspective, and he delivered his first set of lectures in 1811; he continued to give them on a semi-regular basis until 1828, although he did not resign the professorship until ten years later. The intensive period of study that Turner undertook between 1807 and 1811 in preparation for these lectures greatly deepened his aesthetic awareness, and consequently his idealism. By the early 1810s Turner was at the height of his powers, and despite growing critical hostility from the 1820s onwards, he came to be generally regarded as Britain's leading painter. Public knowledge of his works was widely disseminated through engraved reproductions of his oils and of finished watercolours made for that purpose; eventually over 800 of his images were copied by engravers, and naturally he accrued a good deal of his income from creating for, and supervising that activity, although he had also been able to command high prices for his oils and watercolours from fairly early on in his career. Turner was enormously prolific, producing some 550 oil paintings, nearly 2000 highly detailed and meticulously finished watercolours, and over 19,000 sketches and preparatory studies, the latter groups of works being mostly held in the Turner Bequest at Tate Britain. (In the following entries the abbreviation T.B. denotes that holding.)

13

JOSEPH MALLORD WILLIAM TURNER, RA, 1775–1851

Malmesbury Abbey
c. 1791, pen and brown ink and watercolour, 19 × 26.1 cm (7½ × 10¼ in.)
Bacon Inventory Number: I/A/20

The first of Turner's many tours, in 1791, when he was just sixteen, took him to Bristol and South Wales *via* Malmesbury. Its ruined twelfth-century Benedictine abbey was a natural subject, having been represented many times by topographical artists. We see it here in evening light.

Originally this sheet may have formed a leaf in the *Bristol and Malmesbury* sketchbook (T.B. VI) used on the 1791 tour. The draughtsmanship is assured, the colours rich, the composition striking, with the foreground tree both framing the scene and dramatically enhancing its depth.

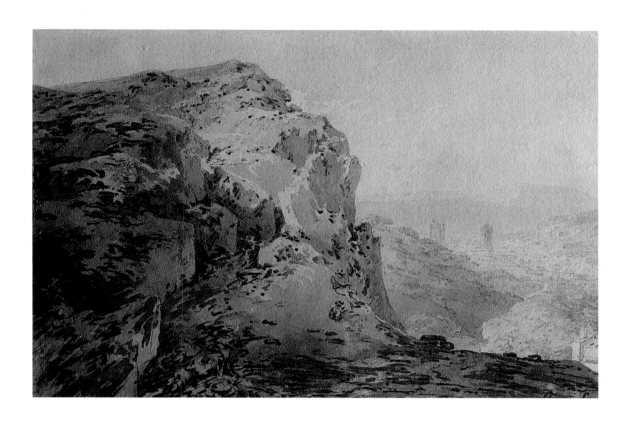

14

JOSEPH MALLORD WILLIAM TURNER, RA, 1775–1851

The Vale of Bath from Kingsdown Hill
c. 1792, signed lower right and inscribed on the reverse of the mount, pencil and watercolour,
17.4 × 26.35 cm (6⅞ × 10¼ in.)
Bacon Inventory Number: I/A/31

Through an oversight this work was omitted from the standard listing of all of Turner's known watercolours (see Wilton 1979). The painter passed through Bath on his way to South Wales in the summer of 1792 when he made the pencil drawing annotated "Kingsdown Georges Road" from which he subsequently developed this watercolour (T.B. XXII-O).

The design depicts the panorama looking westwards in midday light towards the towers of Bath Abbey (on the left) and of the church of St Michael-extra-Muros (on the right). The latter building was demolished sometime before 1836. At the lower right can be seen one of the house chimneys in Bathford village.

The style of the signature is typical of 1792, and the drawing enjoys a wide tonal range that suggests that it was made in the summer of that year, when the artist began to widen his control of light and dark. This expansion would continue, and eventually have the widest possible ramifications for Turner's development as a colourist.

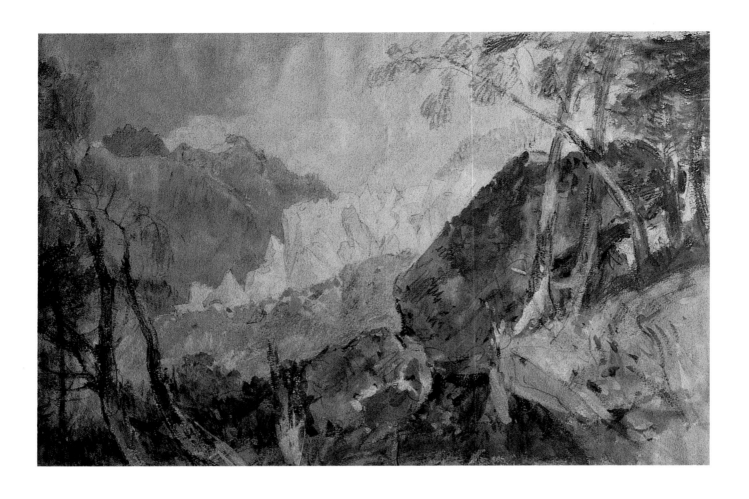

15

JOSEPH MALLORD WILLIAM TURNER, RA, 1775–1851

The Glacier de Bossons, near Chamonix, Savoy
c. 1802, pencil and watercolour heightened with white on grey paper, 32 × 47.6 cm (12⅝ × 18¾ in.)
Bacon Inventory Number: I/A/1

In the summer of 1802 the cessation of hostilities with France enabled Turner to visit French Savoy, Switzerland and the Val d'Aosta. He was especially drawn to the valley of the River Arve at Chamonix, and later made five finished watercolours depicting that landscape and the adjacent Mer de Glace; in one of them (Whitworth Art Gallery, Manchester; see Wilton 1979, no. 387) we look from the Montanvers mountain towards the Glacier de Bossons, with Mont Blanc towering above it.

Hickman Bacon bought this expressive but fairly monochromatic watercolour from John Ruskin. It shows the glacier and Montanvers beyond it, to the left. The vigour of the draughtsmanship suggests that it may have been drawn from nature, although Turner never made a habit of working out of doors, preferring to elaborate his works in his lodgings or back in London from sketches taken on the spot.

16

JOSEPH MALLORD WILLIAM TURNER, RA, 1775–1851

A Boat and Red Buoy in a Rough Sea
c. 1830, pencil and watercolour heightened with white gouache on blue-grey paper, 13.9 × 19 cm (5½ × 7½ in.)
Bacon Inventory Number: I/A/13

Around 1830 Turner created a group of watercolours on blue-grey paper (see Wilton 1979, nos. 914–27). All of them incorporate touches of gouache and are about the same size as the present drawing, which suggests that it also belongs to that set. One of the watercolours clearly depicts the Chain Pier at Brighton (Yale Center for British Art, see Wilton 1979, no. 917), so there may be some truth in Ian Warrell's suggestion that the white cliffs seen here in the distance on the left are the ones that stretch eastwards from Brighton.

If this watercolour does date from about 1830, then Turner may have remembered the striking pictorial effect a dab of red exerts within a monochrome context. In the 1832 Royal Academy Exhibition he revenged himself upon John Constable by placing a red buoy amid the similarly cool tonalities of an oil painting, *Helvoetsluys* (private collection, see Butlin and Joll 1984, cat. 345), which was hanging next to a picture by Constable. Turner did so in order to make Constable's reds look weak, and he succeeded, for the latter grumbled, "He has been here and fired a gun".

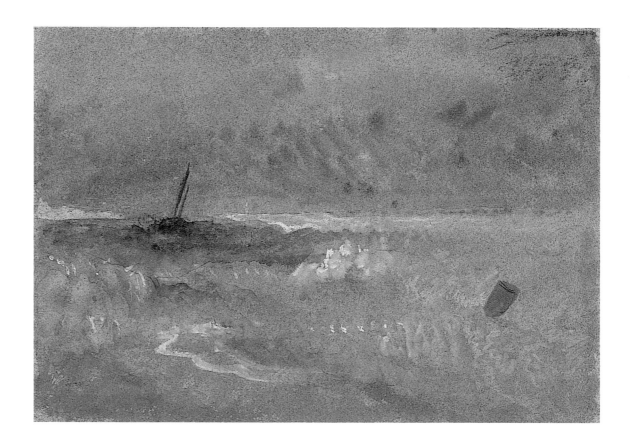

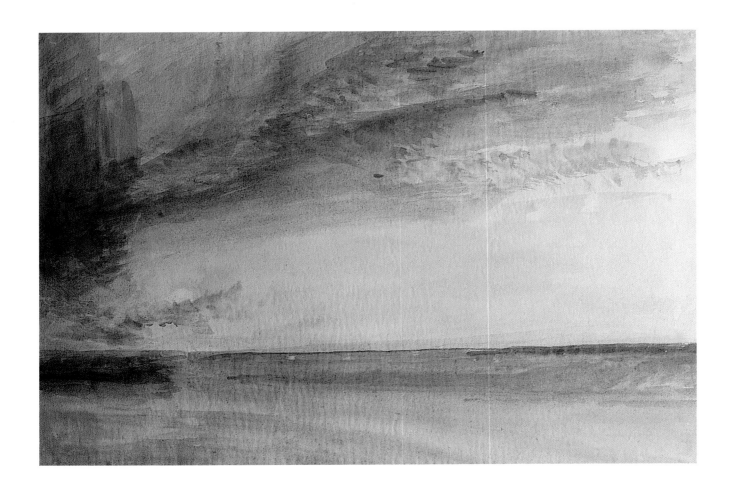

17

JOSEPH MALLORD WILLIAM TURNER, RA, 1775–1851

Low Sun and Clouds over a Calm Sea

c. 1835, watercolour, 24.1 × 35.8 cm (9½ × 14⅛ in.)

Bacon Inventory Number: I/A/32

Although this work has traditionally been known as 'Red and blue sunset sky over the sea', the absence of the moon means we cannot tell if it is a sunset or a sunrise. On the horizon below the sun Turner has washed some red, rather than leave the paper white to obtain the brilliant reflection of the orb. However, the sun is presumably masked by the intervening cloud at that point, which is evidently why Turner gave us the red.

As Peter Bower has pointed out, this watercolour was painted on a sheet of extremely thin writing paper that may well originally have been made for use in ledger books. Given the relative simplicity of the image it could be that Turner was testing the paper for its behaviour when employed as a watercolour support. The small blob of deep red in the sky at the centre testifies that it was able to hold intense colours rather well.

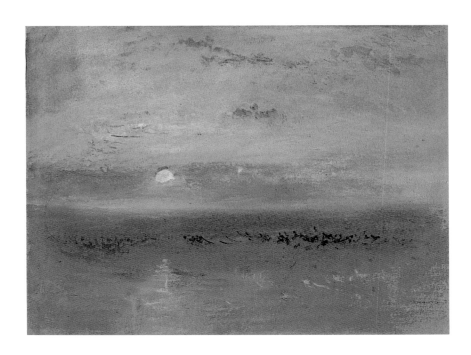

18

JOSEPH MALLORD WILLIAM TURNER, RA, 1775–1851

A Low Sun

c. 1835–40, watercolour and gouache on buff paper, 22.6 × 29.5 cm (8⅞ × 11⅝ in.)
Bacon Inventory Number: I/A/23

As Peter Bower has determined, both this work and cat. 19 are on sheets of an identical buff-coloured wove paper that was originally created for drawing with chalks and which once belonged in the same Royal Quarto-sized sketchbook. It has been argued (see Yardley 1984, pp. 53–55) that the sketchbook was the same one that was later sold to John Ruskin by Turner's Margate and London housekeeper, Sophia Caroline Booth. Ruskin subsequently disassembled that sketchbook, which is why its constituent watercolours are now in a number of public and private collections. However, it remains to be proved through the comparison of paper types whether this watercolour and cat. 19 did in fact formerly belong in that sketchbook.

Although the present drawing has traditionally been titled 'Sunset', that identification seems unsafe. While a small touch of white gouache above and to the left of the sun could denote a new moon – in which case we would be witnessing a sunset, for the moon appears to the left of the sun at the end of day – another dab of white in a lower position to the right of the sun could equally denote the moon, in which case we would be seeing a dawn scene (for the moon appears to the right of the sun before dawn).

Whatever the hour of the day represented, the beauty of the view is not at issue. The few dark touches distributed across the sea fortify the vista by enhancing its colouristic depth and spatial recession.

19

JOSEPH MALLORD WILLIAM TURNER, RA, 1775–1851

Figures on a Beach
c. 1835–40, watercolour and gouache on buff paper, 22.6 × 29.2 cm (8⅞ × 11½ in.)
Bacon Inventory Number: I/A/3

Like cat. 18, this watercolour also originally belonged in a Royal Quarto sketchbook, and possibly the one later disassembled by Ruskin. The work has suffered some paint loss and, judging by a reflection on the sands to the right of centre, the areas affected included a depiction of the moon. Because of the absence of the orb we cannot tell if this is an evening or a morning scene.

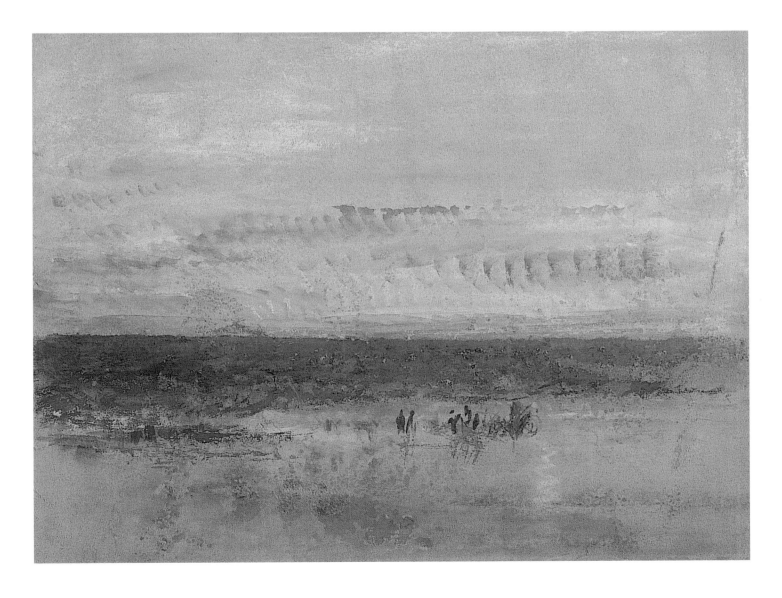

20

JOSEPH MALLORD WILLIAM TURNER, RA, 1775–1851

A Rough Sea beating against Margate Jetty, with Margate Pier beyond
c. 1840, pencil, stopping-out and watercolour heightened with white gouache on grey paper,
19.3 × 28.8 cm (7⅝ × 11⅜ in.)
Bacon Inventory Number: I/A/15

This drawing is not recorded in the standard listing of Turner's watercolours, although it is indubitably from the artist's hand. As Ian Warrell has convincingly suggested, we are looking at the long jetty that stood almost opposite Turner's lodgings at Margate, with the stone-built Margate Pier beyond. The small lighthouse near the seaward end of the pier is represented as a light form against the darker background of blues brushed across the sky. On the left are buildings fronting the small harbour at Margate.

The dramatic crash of the waves, the way the sea is drawn with a total understanding of its underlying motion, and the characteristic bravura of the draughtsmanship, are the salient factors that support the watercolour's attribution to Turner. Some touches of stopping-out varnish in the sea indicate that a degree of forethought went into the design, for Turner habitually used the fluid for his highlights when beginning a drawing and it had to be allowed to dry before further work could take place over it. At the lower left, pencil marks indicate a small boat being tossed by the waves. The strong reds of the buoy and jetty stand out dashingly from the cool colours that surround them, and although it is unlikely they would have been quite so bright in reality, they seem entirely convincing in representational terms.

JOSEPH MALLORD WILLIAM TURNER, RA, 1775–1851

Study of Waves

c. 1840, watercolour and bodycolour on grey paper, 18.8 × 27.4 cm (7⅜ × 10¾ in.)
Bacon Inventory Number: I/A/16

Peter Bower has determined that the paper used for this watercolour and for cat. 20 are identical, and the two sheet sizes are very similar. It seems certain that they each originally formed one-eighth parts of an Imperial Octavo sheet made by the papermakers Bally, Ellen and Steart. As the blues used for the skies in the two drawings are exactly alike, it seems likely that Turner elaborated the images during the same work session.

No painter has ever matched Turner's understanding of the movement of water, and here that insight enabled him to create great art: the waves swirl and crash with both enormous power and the most profound veracity.

JOSEPH MALLORD WILLIAM TURNER, RA, 1775–1851

Fish Market on the Sands
c. 1840, watercolour and bodycolour on grey paper, 13.9 × 19 cm (5½ × 7½ in.)
Bacon Inventory Number: I/A/12

As Peter Bower has further surmised, this watercolour is also on the grey paper used for cat. 20 and 21, although it is roughly half their size – evidently Turner took one-eighth of the same overall Imperial Octavo sheet and then further tore it in half.

At the lower left the people indicated in pencil appear to be gathered around what are probably fish, given their proximity to the sea. To the right some figures push a boat towards the water. The addition of red to the sky augments the intensity of the neighbouring primary colours, although it hardly seems likely that such a red would have been witnessed near a bright sun in reality.

23

JOSEPH MALLORD WILLIAM TURNER, RA, 1775–1851

Evening Landscape with a Tower and Bridge

c. 1840, pencil, watercolour and touches of gouache on white paper prepared with a grey wash,
15.5 × 22.9 cm (6⅛ × 9 in.)
Bacon Inventory Number: I/A/34

Peter Bower has established that the paper used both for this watercolour and for cat. 24 are identical, and the two drawings are virtually the same size. Before making the images Turner laid down grey washes on the white paper.

It has not been possible to identify the topographical subject of this scene. In form and colouring it is reminiscent of Turner's Scottish views but the landscape depicted could as readily be German or Belgian. The reverse of the sheet bears a pencil drawing of an unidentified Continental town.

It would be easy to read the area at the centre as light being reflected off a distant lake or river, with dark-toned shrubbery in front of it. However, as Andrew Wilton has pointed out, the area could instead be interpreted as forming a single-arched bridge, the aperture and supports of which are denoted by the dark tones; its shape is not reflected beneath it because the inversion is apparently masked by a near bank of the river. Some small touches of gouache at the lower right could well have been intended to indicate figures or animals reclining on the river bank. Buildings are signified in pencil at the lower left, and possibly also in watercolour in the distance on the right, although the latter marks could just be agglomerations of pigment.

24

JOSEPH MALLORD WILLIAM TURNER, RA, 1775–1851

A Distant Castle with Poplar Trees beside a River
c. 1840, pencil, watercolour and sepia ink on white paper prepared with a grey wash, 15.5 × 22.8 cm (6⅛ × 9 in.)
Bacon Inventory Number: 1/A/39

Here Turner obtained all of his many highlights by rubbing or washing away the underlying grey wash, whereas in cat. 23 he used the same technique but added some of the light areas and smaller highlights in gouache. The artist had prepared white paper with a grey wash to form the support for his series of fifty views of the Rhine made in 1817. However, it seems unlikely that this drawing was a direct offshoot of that group, for in none of them did Turner rub out highlights as extensively as he has done here (instead, he mostly added them in gouache). Moreover, in overall style and technique this watercolour looks to date from much later. Although the trees drawn in sepia on the right are reminiscent of those appearing in sepia sketches made in the 1810s for Turner's 'Liber Studiorum' designs, the connection with cat. 23 suggested by the identical paper type, and the late style of that other work, preclude the possibility that the present design could date from the 1810s.

The building represented in the distance has not been identified but it may stand in the vicinity of Burg Eltz, near Karden on the River Mosel in Germany, for Turner made a drawing of that medieval castle using exactly the same technique that he employed here, and on a sheet that is virtually identical in size (private collection, see Wilton 1979, no. 1335).

25

JOSEPH MALLORD WILLIAM TURNER, RA, 1775–1851

Mount Pilatus from across the Lake of Lucerne
c. 1842, watercolour, 21.6 × 26.9 cm (8½ × 10⅝ in.)
Bacon Inventory Number: I/A/4

Identification of the massif that dominates this image is assisted by its outline and by the buildings indicated on the extreme right; clearly we are looking westwards towards a somewhat compressed Mount Pilatus in evening light, with Lucerne on the right. Although a line runs across the lake to the left of the steamer, it does not indicate the lake shore, which may be seen further off, beneath the town highlighted on the far left. The gap between these lines clearly denotes the bay that runs around from Seeben to Hergiswill, which is the town represented on the left. A steamer service was introduced on Lake Lucerne in 1837, and Turner represented such a vessel in an 1842 view of the lower reaches of the lake from Brunnen, which suggests that this work could date from around the same time.

Through the researches of Edward Yardley (see Yardley 1988, p. 43), we now possess a detailed provenance for this watercolour: Birket Foster, his sale Christie's 28 April 1894 (as 'Loch Lomond'); bought Agnew's, £46.4s; W.G. Rawlinson; Sir Hickman Bacon; the present owner.

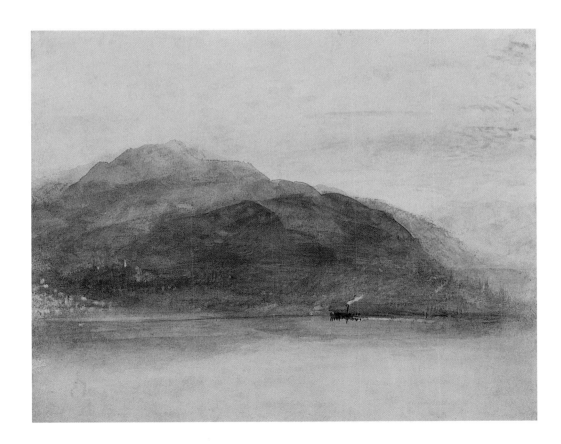

JOSEPH MALLORD WILLIAM TURNER, RA, 1775–1851

The Sarner See, Evening
c. 1842, pen and brown ink, watercolour and gouache, 22.9 × 29 cm (9 × 11⅜ in.)
Bacon Inventory Number: I/A/30

Although this late finished watercolour has always been known as 'The Lake of Brienz', the topography represented does not accord with the surroundings of that body of water. In a letter to the author, David Hill has suggested that the work instead represents the lower reaches of the Sarner See, a lake to the south-west of Lake Lucerne that Turner also possibly depicted elsewhere (see Shanes 2000, p. 237).

Hill's suggestion seems convincing, for it accords with the topography visible when looking in a south-westerly direction towards the Brünig Pass. Evening light falls on the mountain range leading up to the Doldenhorn to the right of centre. The snow-covered Gerstenhorn may be seen to the left, and the Jungfrau further off in the distance beyond it.

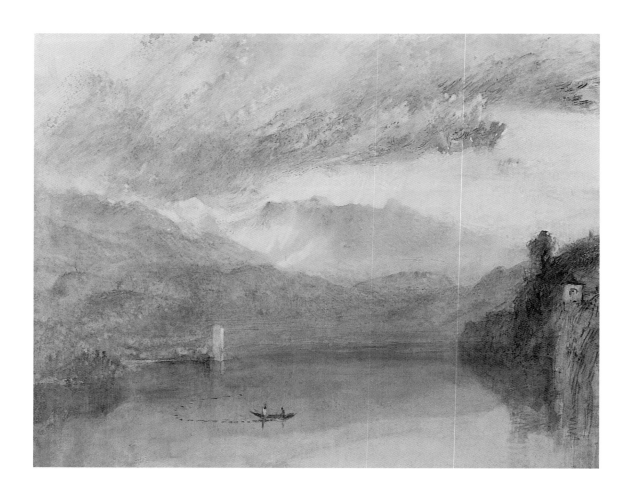

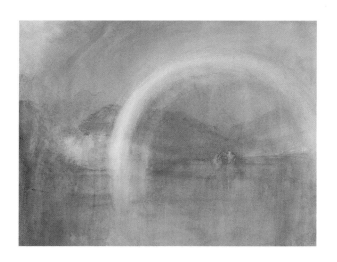

27

JOSEPH MALLORD WILLIAM TURNER, RA, 1775–1851

Rainbow over a Swiss Lake, possibly the Lauerzer See
c. 1844, pencil and watercolour, 22.6 × 28.7 cm (8⅞ × 11¼ in.)
Bacon Inventory Number: I/A/5

The sheet on which this watercolour was made originally belonged in a sketchbook. Traditionally the drawing has been known as 'Loch Awe with a Rainbow' because its framing of a distant building with a rainbow is superficially similar to Kilchurn Castle on Loch Awe as framed by a rainbow in a watercolour Turner exhibited at the Royal Academy in 1802 (Plymouth Art Gallery, see Wilton 1979, no. 344). Such an identification led to the initial belief that the present work was created around 1801, when Turner first toured Scotland. That view was subsequently revised on stylistic grounds, and the work redated to around 1831, when the painter again toured north of the border. However, as Ian Warrell has convincingly pointed out, the extensive pencil work and the mountains depicted suggest that this is in fact a Swiss scene dating from the mid-1840s. Certainly the mountains indicated do not resemble those drawn at Loch Awe by Turner in 1801 in his *Scotch Lakes* sketchbook, T.B. LVI, from which he developed the 1802 watercolour now in Plymouth.

The island to the right of centre generally resembles the Schwanau Island on the Lauerzer See, a small lake about twenty-two kilometres east of Lucerne, Switzerland, that Turner depicted in a watercolour study (private collection, see Wilton 1979, no. 1488) and a finished drawing that might date from as late as 1848 (Victoria and Albert Museum, London, see Wilton 1979, no. 1562). However, the surroundings of the island do not exactly correspond to the topography of the Lauerzer See, for although the mountain indicated in pencil beyond and to the right of the island might denote the adjacent Kleiner Mythen peak, which it closely resembles in shape, it seems too low to represent that crag (moreover, there is no indication of the even higher Grosser Mythen mountain that would be located to the right of it, to the south). The locale represented must therefore still await identification.

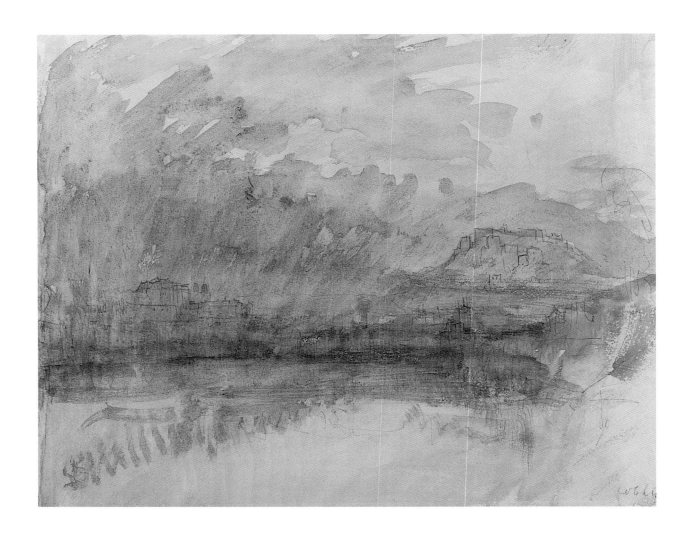

28

JOSEPH MALLORD WILLIAM TURNER, RA, 1775–1851

Coblenz

c. 1844, inscribed *Coblenz* lower right, pencil and watercolour, 23.1 × 29.2 cm (9⅛ × 11½ in.)

Bacon Inventory Number: I/A/9

This is another work drawn on a sheet that originally belonged in a sketchbook, as can be seen from its left-hand edge.

　　We look down the River Rhine, with Coblenz on the left and the Ehrenbreitstein fortress on the right; the great citadel just catches the afterglow of sunset. Early evening was one of Turner's favourite times of day at Ehrenbreitstein, for he portrayed the building lit up at the end of day many times in the first half of the 1840s, not only because it looked glorious in roseate hues but also because its name – the '*bright* stone of honour' – engaged his associative sensibility. As was customary in his depictions of the castle, Turner has doubled its height in relation to the river.

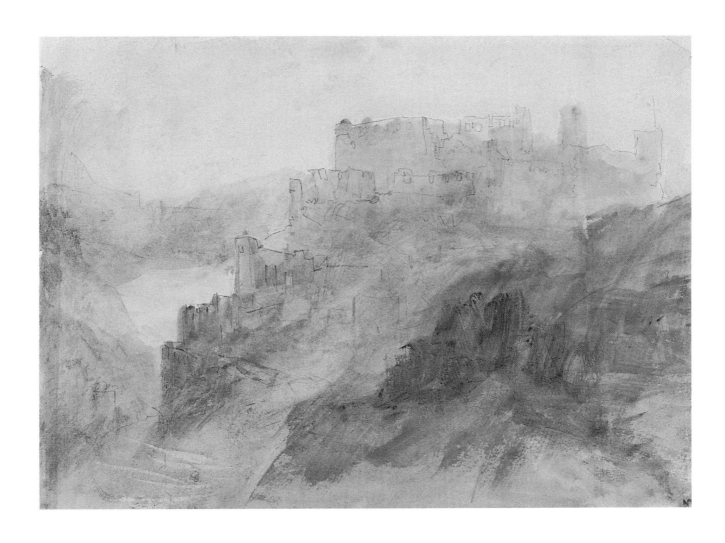

29

JOSEPH MALLORD WILLIAM TURNER, RA, 1775–1851

Burg Rheinfels on the Rhine
c. 1844, pencil and watercolour, 18.5 × 24.1 cm (7¼ × 9½ in.)
Bacon Inventory Number: I/A/29

This watercolour was formerly titled 'A Castle above a Chasm'. However, it has recently been identified as Burg Rheinfels, a thirteenth-century Rhenish toll castle located about thirty kilometres south of Coblenz which was destroyed by the French in 1797 (see Powell 1991, p. 62).

Peter Bower has determined that the sheet on which the drawing was made originally formed part of a sketchbook. We view the castle from the north-west, in evening light. The use of brightly-hued transparent washes over pencil outlines suggests a late date for the work, for it was a technique widely employed by Turner in the final decade of his life.

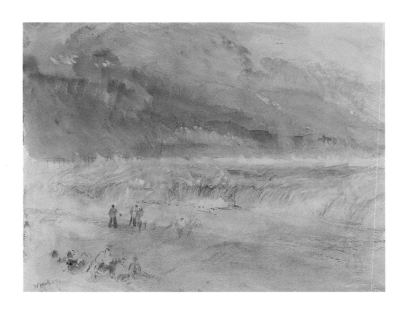

30

JOSEPH MALLORD WILLIAM TURNER, RA, 1775–1851

Wreckers

c. 1845, inscribed *Wreckers* at the lower left, pencil and watercolour, 22.4 × 29.2 cm (8¾ × 11½ in.)
Bacon Inventory Number: I/A/8

The pencil marks indicating a jetty on the left terminate in a large oblong. Were it not for the fact that the pier does not extend very far out to sea it might be thought that we are looking across Calais Sands towards Calais Pier and Fort Rouge, as we do in Turner's 1830 oil painting *Calais Sands, Low Water, Poissards collecting Bait* (Bury Art Gallery; see Butlin and Joll 1984, cat. 334, and also the present cat. 67, where Calais Pier and Fort Rouge are visible in the far distance on the right). However, given the relative shortness of the jetty it seems much more likely that Turner here depicted a pier somewhere in Britain. Moreover, it is uncertain as to whether the sharp-edged forms above the horizon on the right are clouds or cliff-tops. If they are the former, then we could be looking out to sea at Margate, with the jetty represented in cat. 20 on the left (in which case the oblong could indicate the sails of a boat moored at its end); if they are cliffs we could be looking eastwards towards Dover from Folkestone.

Turner's characterization of the people in the foreground as 'Wreckers' is unusual; generally he leaves us to identify the activity of his figures for ourselves. The salvaging of wreckage was vital for the economic survival of the nineteenth-century coastal poor, who could not afford expensive materials such as wood, metal and rope. The breaking waves across the foreshore demonstrate Turner's matchless insight into hydrodynamic motion, as do the rhythms of the sea more generally. By paralleling the line of yellow across the beach, the diagonal formed by the clouds or cliff-tops tightens the pictorial structure, while simultaneously leading the eye into the far distance.

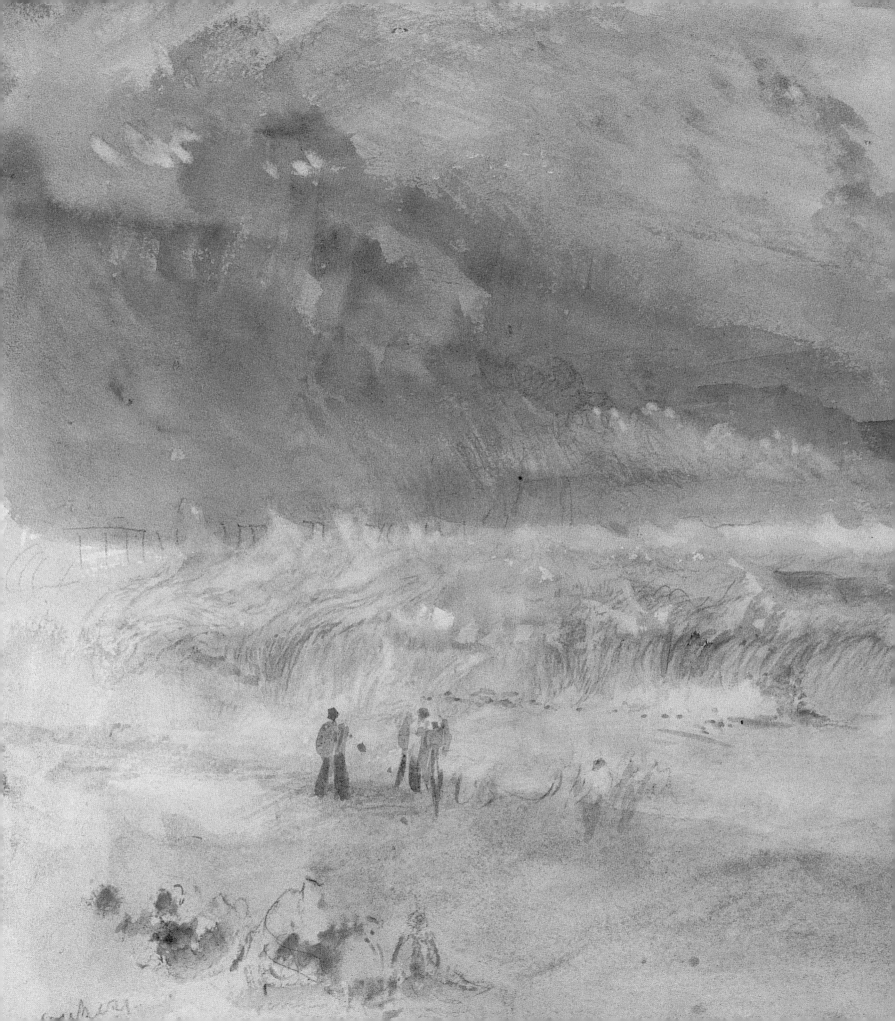

31

JOSEPH MALLORD WILLIAM TURNER, RA, 1775–1851

Study of Clouds and Wet Sand
c. 1845, pencil and watercolour, 22.9 × 29.5 cm (9 × 11⅝ in.)
Bacon Inventory Number: 1/A/17

Peter Bower has ascertained that this sheet once belonged in the same Royal Quarto-sized sketchbook as cat. 30. The cobalt blue and yellow-ochre used respectively for the sky and sands in each drawing are identical, which suggests that Turner made both watercolours during the same work session. After the two initial washes for the present image had dried, the artist added some touches of a deeper cobalt blue, and then dragged a brush laden with a semi-dry accretion of ultramarine blue and deep crimson across the clouds to the right, where their colouristic intensity enhances the dynamism of the sky.

Marks on the horizon at the extreme left resemble the end of the Chain Pier at Brighton, with cliffs perhaps indicated beyond. However, the width of the sands rather precludes this being a Brighton view, for the tide does not go out this far off the Sussex town. In the foreground, at the lower right, are pencilled indications of a boat lying on its side.

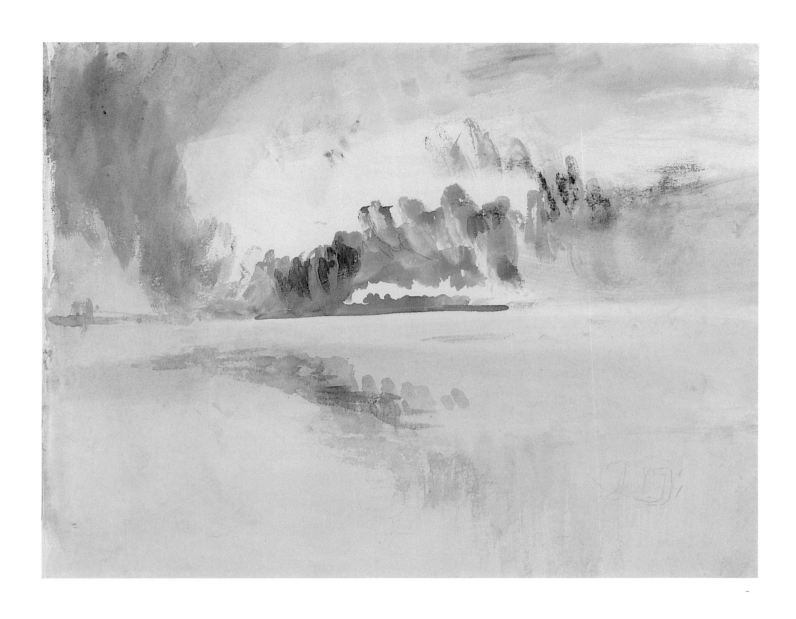

32

JOSEPH MALLORD WILLIAM TURNER, RA, 1775–1851

A Cloudy Sky
c. 1845, red chalk, grey and red wash, 23 × 31.2 cm (9 × 12¼ in.)
Bacon Inventory Number: 1/A/41

As Peter Bower has determined, this watercolour was made on the same paper used for cat. 33 and for three other unexhibited drawings in the Bacon collection (inventory numbers 1/A/10, 1/A/28 and 1/A/44). All of these sheets originally formed pages in a Super Royal Quarto-sized sketchbook. As sheet 1/A/44 is watermarked 'J WHATMAN 1844', we know the earliest possible date by which Turner could have made all five drawings. It seems likely Hickman Bacon bought them simultaneously, in what must have been a job lot.

No work in the Hickman Bacon collection better illustrates the collector's catholicity of taste than this image, for it hovers on the verge of abstraction. Until now the watercolour has been titled 'Fire at Sea' but there is no visual evidence for such an identification of subject. Merely the touches of red at the lower left and upper right suggest fire, and only do so by a considerable stretch of the imagination. The sea is nowhere in evidence, for the shapes made by the lower edges of the brushings of dark grey do not even remotely suggest the characteristic patterns formed by Turner when depicting waves. Nor is this an 'abstract' drawing, for as many watercolour studies in the Turner Bequest prove, such loose, expressive brushwork may have been intended to act as shorthand for very representational imagery indeed.

33

JOSEPH MALLORD WILLIAM TURNER, RA, 1775–1851

Fox Lugger
c. 1845, Fox Lugger inscribed lower left with additional wording, pencil and watercolour, 22.8 × 33 cm (9 × 13 in.)
Bacon Inventory Number: I/A/18 Literature: Wilton 1979, no. 1424

The words 'Fox Lugger' at the lower left are followed by further, indecipherable words ending in the capitals 'MS'. It seems likely that 'Fox' denoted the name of the ship rather than its type.

A lugger is a sailing vessel rigged with lugsails or sails whose width is much greater at the bottom than at the top, which makes for easier handling. The vessel depicted has lost all but the base of her foremast, as well as her entire mainmast and most of her mizzen-mast; a sail billows uncontrollably above her bowsprit. We know that Turner often felt despair at the thought of death in his final years, and maybe this image, of an abandoned boat utterly adrift at sea, articulated his bleakest thoughts.

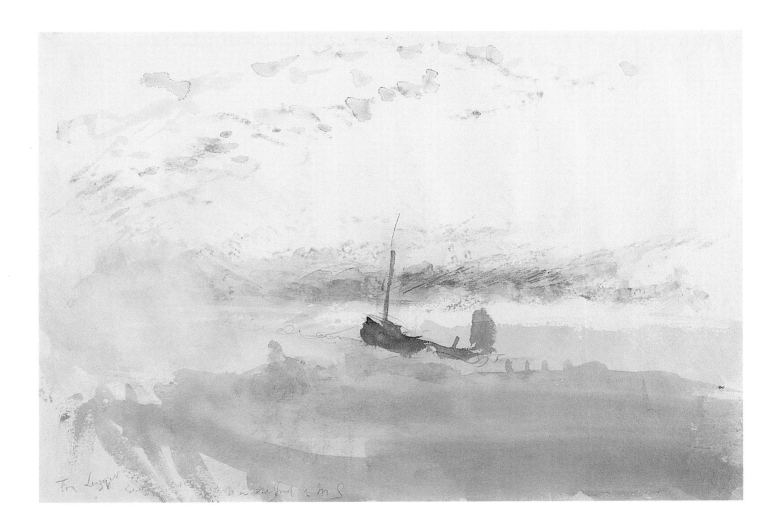

JOSHUA CRISTALL, c. 1767–1847

Cristall was born in Camborne, Cornwall, and he grew up in London where he studied at the Royal Academy Schools. Like Girtin and Turner he attended the unofficial 'Academy' run by Dr Thomas Monro. He lived for a time in Hastings, and travelled extensively throughout Britain. A founder-member of the Society of Painters in Water Colours, Cristall eventually exhibited almost 400 works there, and served three terms as its President. In 1823 he moved to the Wye Valley in Herefordshire but returned to London in 1841.

34
JOSHUA CRISTALL, c. 1767–1847

The River Dee, Llangollen

signed and dated 1802 at the lower left, pencil, pen and grey ink and watercolour, corners cut,
22.2 × 35.8 cm (8¾ × 14⅛ in.)
Bacon Inventory Number: 1/F/4

A powerful sense of energy pervades this image, and the depiction of disturbed water is especially convincing.

35

JOSHUA CRISTALL, c. 1767–1847

Fishermen Mending their Nets
signed and dated 1811 lower left, pencil and watercolour, 31.4 × 39.6 cm (12⅜ × 15⅝ in.)
Bacon Inventory Number: I/F/5

In 1807 Cristall suffered a nervous breakdown as a result of his exertions on behalf of the recently founded Society of Painters in Water Colours. With funds provided by his fellow artists he convalesced in Hastings. From his observations there he developed two impressive watercolours that created a major impact when exhibited at the Society of Painters in Water Colours in 1808. One was a view of the fish market at Hastings (Victoria and Albert Museum, London), which inspired many treatments of the same subject. Among the more notable of these were a watercolour by Thomas Heaphy that was exhibited to great acclaim at the Society in 1809 (private collection), and a superb drawing by Turner dating from 1824 (private collection, see Wilton 1979, no. 510), which connects the loss of British liberties at Hastings in 1066 with the contemporary struggle for freedom in Greece.

Although the title of this watercolour does not specify the locality represented, the line of cliffs in the distance corresponds to those stretching eastwards from Hastings. Moreover, the wide-beamed shallow-draught fishing vessels depicted accord fully with those in use at the town. And the date of the work also supports that locational identification, for Cristall was still elaborating his responses to Hastings in 1811. If Hastings is represented, then we view the scene in morning light.

JOHN CROME, 1768–1821

Crome was born in Norwich, the son of a journeyman weaver and publican. He was self-taught. In 1803 he helped found the Norwich Society of Artists and exhibited regularly in the city thereafter. In 1806 he also made his debut at the Royal Academy, where he exhibited intermittently until 1818. In 1814 he visited Paris and toured Belgium. He died in Norwich.

36
JOHN CROME, 1768–1821

The Blasted Oak
c. 1808, watercolour, 58.4 × 44.5 cm (23 × 17½ in.)
Bacon Inventory Number: III/8

Although Crome's art owed much to Lowlands landscape painting, it also nonetheless marked a significant step forward in the development of an English naturalistic approach to landscape painting, being highly influential upon subsequent 'Norwich School' painters. Both of these characteristics are evident in *The Blasted Oak*. Stylistically the drawing harks back to Jacob van Ruisdael and Jan van Goyen, while equally it projects the stark, expressive character of a particular type of form commonly encountered in Norfolk, where the openness of the countryside makes for the frequent destruction of solitary roadside trees by lightning.

Sadly the sky has faded completely (or possibly it was washed off during the Tate Gallery flood of 1928, when some Bacon collection works were being temporarily stored in the museum). A figure stroking the head of a dog is outlined faintly in pencil on the track to the left of centre.

John Sell Cotman, 1782–1842

Cotman was born in Norwich and attended school there. On moving to London in 1798 he was employed by the leading print publisher Ackermann and was patronized by Dr Thomas Monro, through whom he met Girtin. In 1800 he both made his debut at the Royal Academy and was awarded the Greater Silver Pallet of the Society of Arts. He undertook a number of important sketching tours, including a trip to Wales in 1800 (and possibly also in 1802), and to Yorkshire in 1803, 1804 and 1805; as a result of the last of these explorations he created some of his greatest watercolours, including the *Trees near the Greta River* seen here (cat. 42).

Around the beginning of 1802 Cotman joined the Sketching Society, and between 1802 and 1804 occasionally presided over its meetings. In 1806 he failed to be elected to the Society of Painters in Water Colours and returned to Norwich, where he set up as a portrait painter and joined the Norwich Society of Artists, with whom he exhibited for the first time in 1807. Rather disastrously for his own creativity, by 1810 he had established himself as a "drawing master or pattern drawer for young ladies", which activity would eventually lead to the production of large numbers of Cotman-like works, the pedigree of which it is now impossible to establish. In 1812 he moved to Yarmouth where he supplied architectural drawings to the wealthy banker and antiquarian Dawson Turner, who had previously employed John Crome in that capacity; Cotman also taught drawing to Dawson Turner's daughters. In 1817, 1818 and 1820 Dawson Turner was the moving force behind Cotman's tours of Normandy.

Cotman returned to Norwich in 1823, where he opened a school of drawing. In 1825 he became an Associate Member of the Society of Painters in Water Colours. In 1826 he suffered a particularly bad spell of depression, a condition to which he became increasingly prone. He was elected President of the Norwich Society of Artists in 1833. After 1834 he resided in London, where he had obtained the post of Professor of Drawing at King's College School. During this last period of his life he had his sons help him in producing works to meet demand and, as a result, there are a large number of drawings classified as Cotmans that might well be by his highly talented offspring. Cotman made his last tour of Norfolk in 1841 and died in London.

Stylistically Cotman's work passed through several phases, each of which can be illustrated by watercolours in the Bacon collection. First, between 1800 and 1804, he used watercolour in a richly romantic and expressive way. Next came a phase lasting through to the mid-1810s when he used the technique more objectively, with much emphasis on cool colours, flat, tonal washes and simplified forms. This is generally regarded as Cotman's finest creative period. In the subsequent phase a greater richness of colouring and graphic sharpness of detail appears, while in the final period a thickening paste added to watercolour pigment helped Cotman attain a far greater surface expressivity. But throughout each of his stylistic periods Cotman was always an outstandingly individualistic and original painter who displayed a superb sense of form and brilliant responsiveness to tone and colour. He was equally good at depicting land and seascapes, architecture and weather effects, and he was a notable etcher, his best prints of buildings in Norfolk and Normandy being among the finest such works in British art.

37

JOHN SELL COTMAN, 1782–1842

Brecknock

c. 1801, watercolour, 37.6 × 54.6 cm (14¾ × 21½ in.)

Bacon Inventory Number: III/4

This highly atmospheric watercolour may have been exhibited at the Royal Academy in 1801 (no. 311). 'Brecknock' was the medieval name for Brecon, a town that Cotman had visited sometime early in July 1800, on his tour of Wales.

Technically Cotman here used watercolour almost like oil paint, as an expressive and virtually opaque medium; only the washes in the sky enjoy much transparency. The placing of the lightest area of the image near the centre leads the eye into the distance and adds to its depth. Like many of his contemporaries Cotman was aware of the transformation of Britain by industrialization, and the obliteration of architectural character in the process, which is surely why he was so responsive to the decaying old buildings here.

38

JOHN SELL COTMAN, 1782–1842

Tintern Abbey by Moonlight
signed lower right, *c.* 1802, pen, brown ink and watercolour, 39.1 × 26.4 cm (15⅜ × 10⅜ in.)
Bacon Inventory Number: I/B/22

As this drawing demonstrates, Cotman's powers as an architectural draughtsman equalled those of Girtin and Turner, and thus establish him as one of the finest such artists of his generation. Nor was he a stranger to feeling when responding to a building that typified the loss of the past for many of his contemporaries. Extremes of light and dark both invest the shadowed areas with mystery and enhance the immense spatiality, the scale of which is established by the two figures entering the ruins. Although the source of light in the foreground is not apparent, the warm glow created by it underlines the silveriness of the moonlight through contrast. Rubbed textures of the type that are commonly encountered in Cotman's work between 1800 and 1805 impart surface variety to the image, while subtly enhancing its dynamism.

39

JOHN SELL COTMAN, 1782–1842

Scene in the Black Country
c. 1802, watercolour, 25.4 × 45.7 cm (10 × 18 in.)
Bacon Inventory Number: I/B/24

Although this vivid image captures the very spirit of the Industrial Revolution it was never exhibited by Cotman, and nor was it ever recorded in any of his sales. The title given above was the one Hickman Bacon used for the watercolour, clearly because he had purchased it under that name. More recently the work has come to be called 'Bedlam Furnace, near Ironbridge, Shropshire', but as there is no visual or direct documentary evidence to support such a precise identification of the subject, the original title has been used here. It could well be that Cotman wished the drawing to act as a generalized image of the industrial landscape, rather than to denote a specific place.

Whereas artists like Wright of Derby and de Loutherbourg painted industrial scenes with a certain amount of formal objectivity, here Cotman pulled out the expressive stops, rubbing the paper in the centre to obtain a high degree of textural variety; as a consequence, all seems heat and light. The drawing of foliage to left and right presages the stylistic approach to arboreal form that would become more common in Cotman's work after about 1805.

40

JOHN SELL COTMAN, 1782–1842

The Swallow Falls, North Wales
signed and dated 1803 at the lower left-centre and signed in pencil on the verso,
watercolour, 21.1 × 32.5 cm (8¼ × 12¾ in.)
Bacon Inventory Number: III/3

This highly dramatic image has previously been known simply as 'The Waterfall', but it undoubtedly represents the Llyn Ogwen lake and Swallow Falls waterfall on the river Llygwy in Caernarfonshire, North Wales, which Cotman possibly visited in July 1802. As in the three previous works discussed, the artist exercised the maximum tonal range throughout the design, and rubbed textures again make an appearance. A thorough grasp of the behaviour of water is readily apparent.

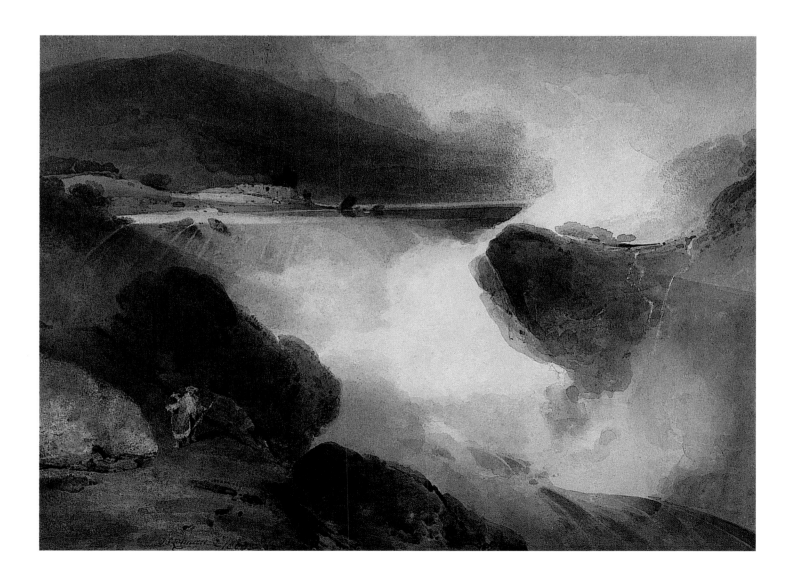

41

JOHN SELL COTMAN, 1782–1842

Norwood Church, Middlesex

twice signed and dated 1803 in the centre and at the lower right-centre, watercolour, 50.8 × 30.5 cm (20 × 12 in.)

Bacon Inventory Number: I/B/7

Indigo pigment is notorious for fading and discoloration, and its use might well explain the lightening and reddening of parts of the sky and ground here. As a slightly darker band across the top of the design demonstrates, that area was once covered by a frame that permitted a little more of its original colouring to survive.

Cotman's signing and dating of the drawing across two headstones is a witty touch, albeit not a very original one, for it was almost a commonplace in depictions of English churchyards. Thankfully the artist would be buried long after 1803 (and then in St John's Wood Churchyard, London).

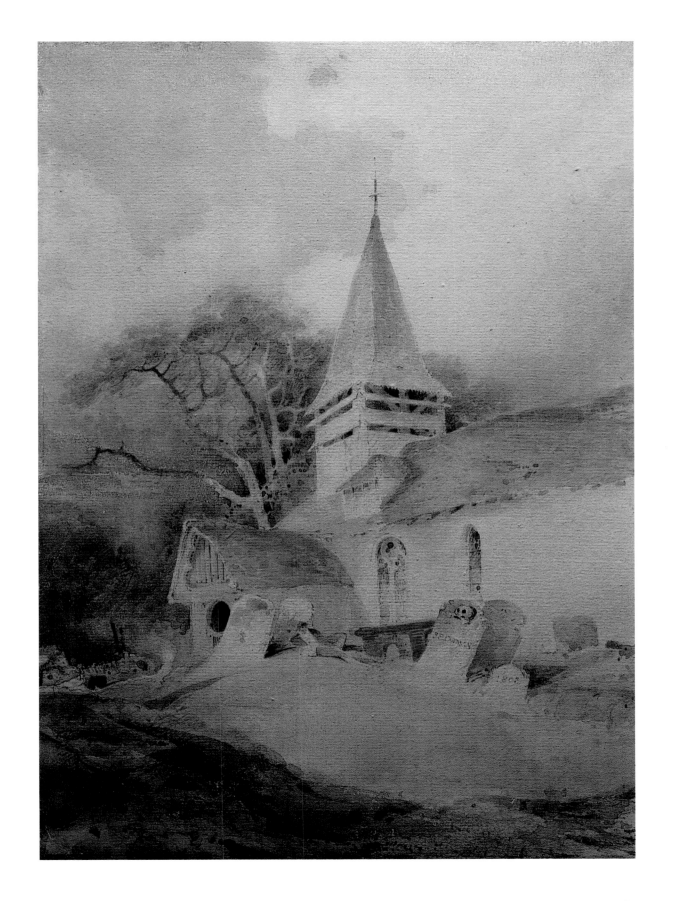

42

JOHN SELL COTMAN, 1782–1842

Trees near the Greta River

c. 1805, pencil, watercolour and touches of blue gouache, 33 × 22.9 cm (13 × 9 in.)

Bacon Inventory Number: III/5

Cotman spent the entire month of August 1805 at Greta Bridge, near Barnard Castle, County Durham, and he was so profoundly delighted by the locale that it transformed his style. Because he needed to find a fresh approach to the beauties and visual complexities of the landscapes that surrounded him, he exchanged the expressive technique he had previously employed for a more distanced response to form and colour. The resulting classicism owed much to Nicolas Poussin and his followers who had similarly used flattened shapes both to project an emotional equilibrium and to create planar recession.

In works such as cat. 44 we can witness the mature expression of Cotman's new objectivity, but here we apprehend him moving towards his goal. By leaving the trees in the centre underworked, the painter simplified and thus clarified what must have been a massive confusion of forms in reality. Only the shapes in the foreground are carefully outlined, and their sharp definition helps offset the looser representation beyond.

43
JOHN SELL COTMAN, 1782–1842

Richmond, Yorkshire
c. 1805, watercolour, 33.9 × 44.1 cm (13⅜ × 17⅜ in.)
Bacon Inventory Number: I/B/2

Like cat. 42, this watercolour was made during the evolution of Cotman's new, objective style. Peter Bower has determined that both drawings, as well as cat. 44 and 46, were made on an absorbent wrapping paper that slightly drained colours of their intensity but helped them attain a greater tonal flatness. That evenness was welcomed by Cotman, for it furthered the emotional reticence of his images.

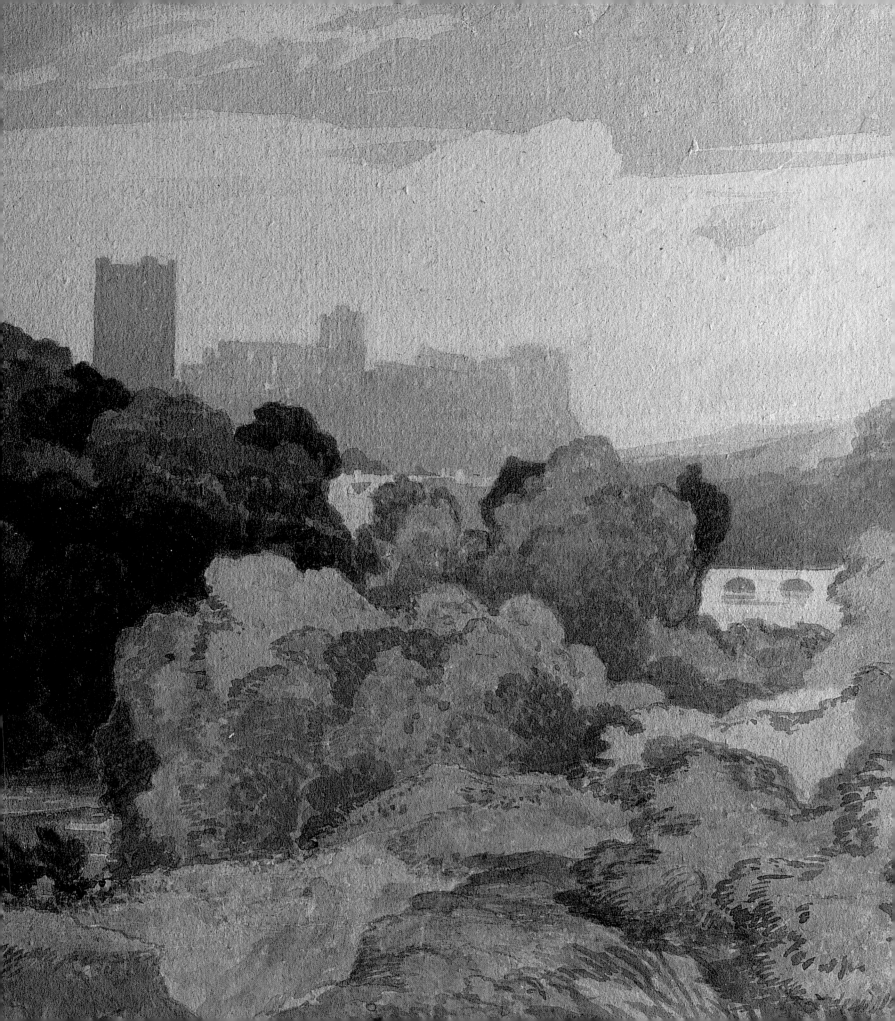

44

JOHN SELL COTMAN, 1782–1842

New Bridge, Durham
c. 1805, pencil and watercolour, 43.9 × 32.5 cm (17¼ × 12¾ in.)
Bacon Inventory Number: I/B/23

With this watercolour we can see Cotman's arrival at a new and more serene approach to the ordering of the world. The use of a cool palette on an absorbent wrapping-paper support, in order to flatten the forms tonally, imparts a highly distinctive lyricism to the image.

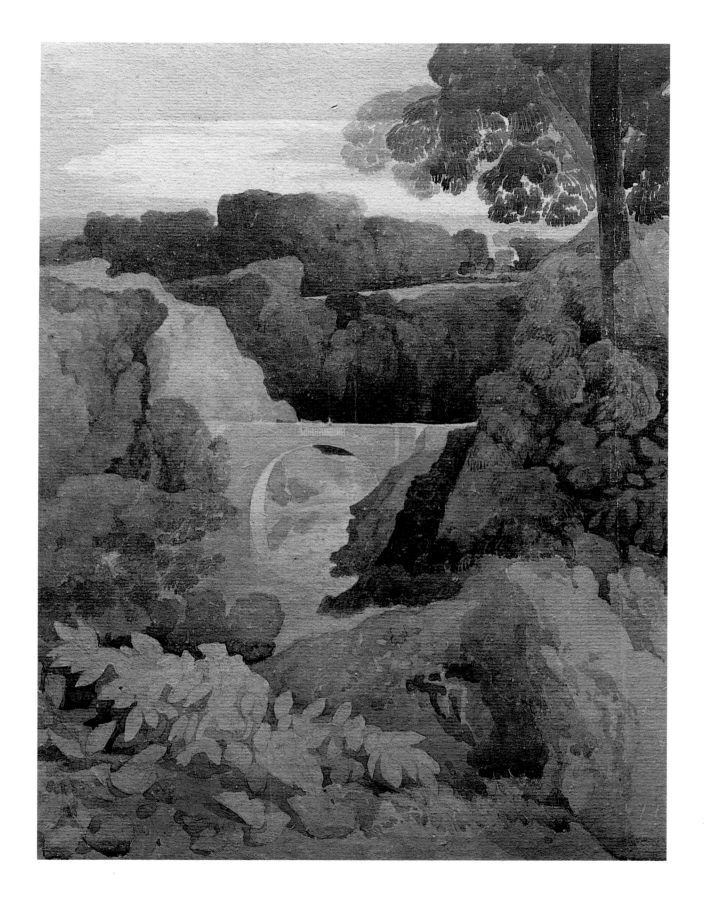

45

JOHN SELL COTMAN, 1782–1842

A Beached Barge near Battersea Bridge
c. 1809, watercolour, 33 × 28.8 cm (13 × 11⅜ in.)
Bacon Inventory Number: II/C/22

Certain features of this watercolour, most notably the depiction of the trees, dog and objects on the beach, have led to doubts that the work is wholly by John Sell Cotman, or even that it is by him at all. However, evidence has recently emerged which suggests that these fears are unfounded.

The conservator Christie Wyld has discovered that the sheet is pasted on to two undersheets, both of which also carry watercolour sketches painted very much in the artist's authentic 1805–10 style. (It seems highly unlikely that, if the watercolour was made by an imitator, the latter would have aped Cotman's style on supportive backings that would never be seen.) Moreover, Peter Bower has identified those undersheets as being paper types that Cotman is known to have used in the 1805–10 period. These factors suggest that the drawing is a genuine Cotman. The artist is known to have sketched Cheyne Walk just across the Thames from this vista when he was in London on his honeymoon in 1809, and even worked up a watercolour from his sketch (Castle Museum, Norwich), so the present drawing could well date from the same time.

The belief that this is a genuine John Sell Cotman is also buttressed by the pictorial strengths of the image. These include the representation of the bridge; the shapes of the clouds; the drawing of the foreshore; the clarity with which the chain extending from the beached barge stands out from the boat; and especially the depiction of water at the lower left. Certainly the work displays an authentically Cotmanesque crispness of design, flatness of tones and inventive distribution of colours, with its strongest hues placed in the centre where their intensity most effectively contrasts with all the surrounding cooler colours.

46

JOHN SELL COTMAN, 1782–1842

A Screen, Norwich Cathedral
c. 1811, pencil and watercolour, 33 × 22.9 cm (13 × 9 in.)
Bacon Inventory Number: I/B/20

This drawing was possibly a study for a slightly larger, marginally more distant and warmer view of the same subject now in the British Museum, London. In turn, that drawing was exhibited at the Norwich Society of Artists in 1811 and was intended for engraving in Cotman's 'Illustrations for Blomefield's *Norfolk*'. The screen represented separates the south transept from the ambulatory; the wooden partition, steps and gallery on the left have since been demolished.

Again, Cotman's outstanding skills in representing architecture are fully evident. As in the finished work, he intensified the sharp definition and spatiality of the screen by surrounding it respectively with less-focused forms and with the highly flattened tones produced by the use of an absorbent wrapping-paper support.

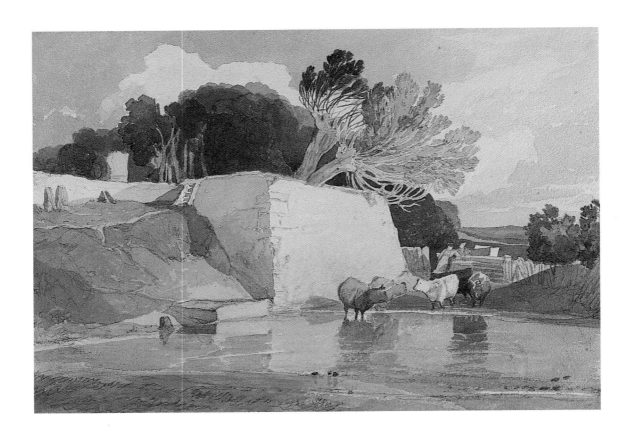

47

JOHN SELL COTMAN, 1782–1842

Cattle Watering
c. 1808, pencil and watercolour, 22.8 × 32.3 cm (9 × 12¾ in.)
Bacon Inventory Number: II/C/16

Reservations have occasionally surfaced that this watercolour is fully the work of John Sell Cotman. These are mainly because the amount of pencil work it contains seems untypical, as does the lack of tonal separation in some of the washes used to represent water (especially those on the left). However, Cotman often allowed his pencillings to remain visible through his transparent watercolour washes (and he even pencilled over them on occasion – see cat. 51 and 52, for example), while elsewhere the tonal control seems quite masterful. This is especially the case with the finely judged tones employed for the shadowed side of the stone structure in the centre. Moreover, the drawing contains many other Cotmanesque characteristics and strengths. These include the drawing of the fence on the right; the depiction of figures at the gate; the bright red used for the hat of one of them; the representation of the pollarded willows and other trees beyond; the shapes of cattle and cloud forms; and the overall beauty of light attained through a masterful distribution of flat tones and warm-cool colour polarities.

48

JOHN SELL COTMAN, 1782–1842

Figures on the Ramparts at Domfront, Normandy
c. 1820, pencil and watercolour, 17.7 × 27.9 cm (7 × 11 in.)
Bacon Inventory Number: II/C/13

Cotman found Domfront "extremely grand" when he stayed there for a week in August 1820, on his third and final tour of Normandy. The twelfth-century castle rises sixty metres above the town, and we see part of its north-east corner here, with the locals taking their ease in the morning sunshine. In the distance is the sea and the Cap de la Hève near Le Havre.

49

JOHN SELL COTMAN, 1782–1842

A Windmill
c. 1828, pencil, pen, brown ink and watercolour, 52.7 × 38.1 cm (20¾ × 15 in.)
Bacon Inventory Number: I/B/8

The graphic incisiveness with which the windmill is drawn, and the flatness of the sky around it, have engendered suggestions that this drawing might well be by Cotman's eldest son, Miles Edmund. However, such features can certainly be witnessed in signed works by the painter made in and around 1828 (for example, a drawing of Alençon in Birmingham Art Gallery; see Rajnai 1982, p. 133). Moreover, the area of vegetation and heathland to the left, with its soft brushed tones and gently rubbed accents, look fully to be by Cotman, while the pictorial punch, architectural and human characterization, stylish depiction of water, depth of tone and richness of colour are highly representative of the artist on a very good day in the late 1820s.

50
JOHN SELL COTMAN, 1782–1842

Figures in a Park
late 1830s?, signed lower right, pencil and watercolour, 26.2 × 35.6 cm (10¼ × 14 in.)
Bacon Inventory Number: I/B/18

Although it has been suggested that this work was either made with the assistance of Miles Edmund Cotman or was fully created by him, the drawing of the trees on the left (especially throughout their upper levels) and of the plant forms at the lower right seems authentically Cotmanesque.

Cotman frequently used a deep ultramarine blue in his later watercolours, and here that colour greatly intensifies the pictorial impact of what might well be an invented landscape. The entire scene enjoys a windswept quality that is heightened by the contrast between the swirling shapes of clouds and trees, and the rigidity of the stone blocks in the foreground. The letters PRQ near the lower left surely form an acronym; the capitals VN are also pencilled nearby.

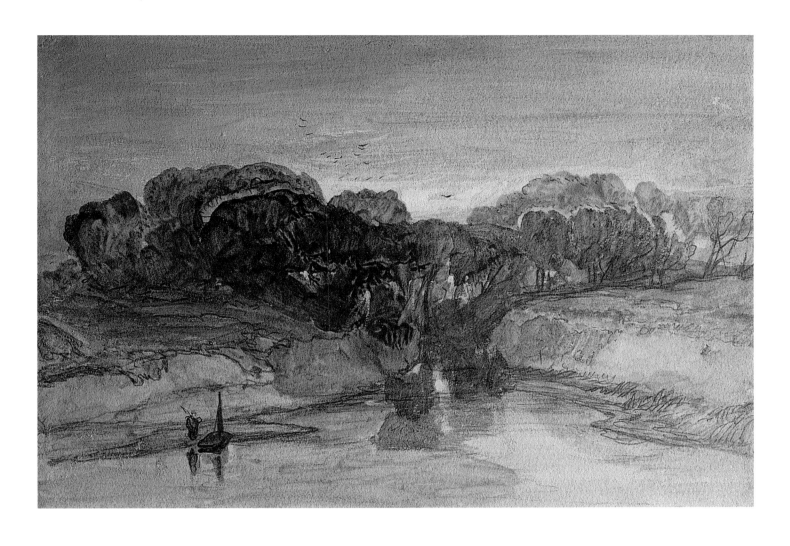

51

JOHN SELL COTMAN, 1782–1842

A River Bank with Trees
1830s?, pencil, watercolour mixed with paste, and gouache, 18.7 × 26.9 cm (7⅜ × 10⅝ in.)
Bacon Inventory Number: I/B/17

The watercolour medium used for the trees that cross this image was a thin coagulated liquid that had risen to the top of fermented flour paste. In his later years Cotman often added such a thickening agent to his watercolour pigments in order to obtain textural and expressive richness.

Here the artist employed the agent to thrilling effect – indeed, few watercolours made anywhere in the first half of the nineteenth century enjoy such enormously expressive brushwork. Not for nothing did David Cox once own this drawing.

52

JOHN SELL COTMAN, 1782–1842

An Open Landscape with a Farmer in a Blue Coat
late 1830s?, pencil, watercolour mixed with paste, and gouache, 20.3 × 28.8 cm (8 × 11⅜ in.)
Bacon Inventory Number: I/B/19

Clearly this image is the direct descendant of earlier Cotman views of relatively empty places, such as *The Ploughed Field* of around 1808 (Leeds City Art Galleries), *Mousehold Heath, Norwich* of around 1810 (British Museum, London) and *The Shepherd on a Hill* of 1831 (Walker Art Gallery, Liverpool). Like them it both exudes fresh air and captures the very essence of English rural life.

An inventive range of textures was imparted to the image by the addition of flour paste liquid to the watercolour. The deep blue of the farmer's smock acts as an ingenious foil to the soft reds, greens and greys around it, while the opacity of that colour establishes the solidity of the figure and firmly anchors it in space.

53

JOHN SELL COTMAN, 1782–1842

Cader Idris
c. 1835, signed lower left, watercolour with touches of gouache, 23.5 × 39 cm (9¼ × 15⅜ in.)
Bacon Inventory Number: I/B/14

This drawing has traditionally been known as 'On the Downs', but the mountains represented are similar to those at Cader Idris in North Wales as depicted by Cotman in a watercolour dating from around 1835 (British Museum, London). It is therefore likely that the massif also formed the subject of the present work.

The distant figures are perhaps two adults and a child, and collectively they establish the vast scale of the landscape. Again we see the strong blues favoured by the older Cotman, while the tiny red accent formed by what might well be a woman's skirt intensifies the contrasting primary colours ranged nearby.

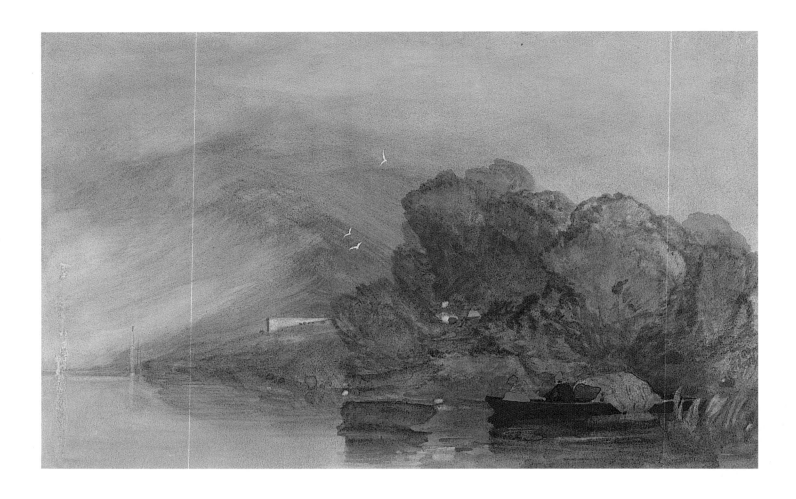

54

JOHN SELL COTMAN, 1782–1842

A Figure in a Boat on a River

1830s, watercolour and gouache, 17.8 × 27.9 cm (7 × 11 in.)
Bacon Inventory Number: II/C/12

Although the drawing of the trees on the right of this watercolour has engendered suspicions that it was executed by Miles Edmund Cotman, the simplicity of the image, its spatial depth, the brushwork in the sky beyond the birds, those gulls themselves, the drawing of both the rushes at the lower right and of the cover of the boat, plus the decisive way the reds in the foreground set off all the surrounding blues, strongly suggest the unaided and inventive hand of John Sell Cotman.

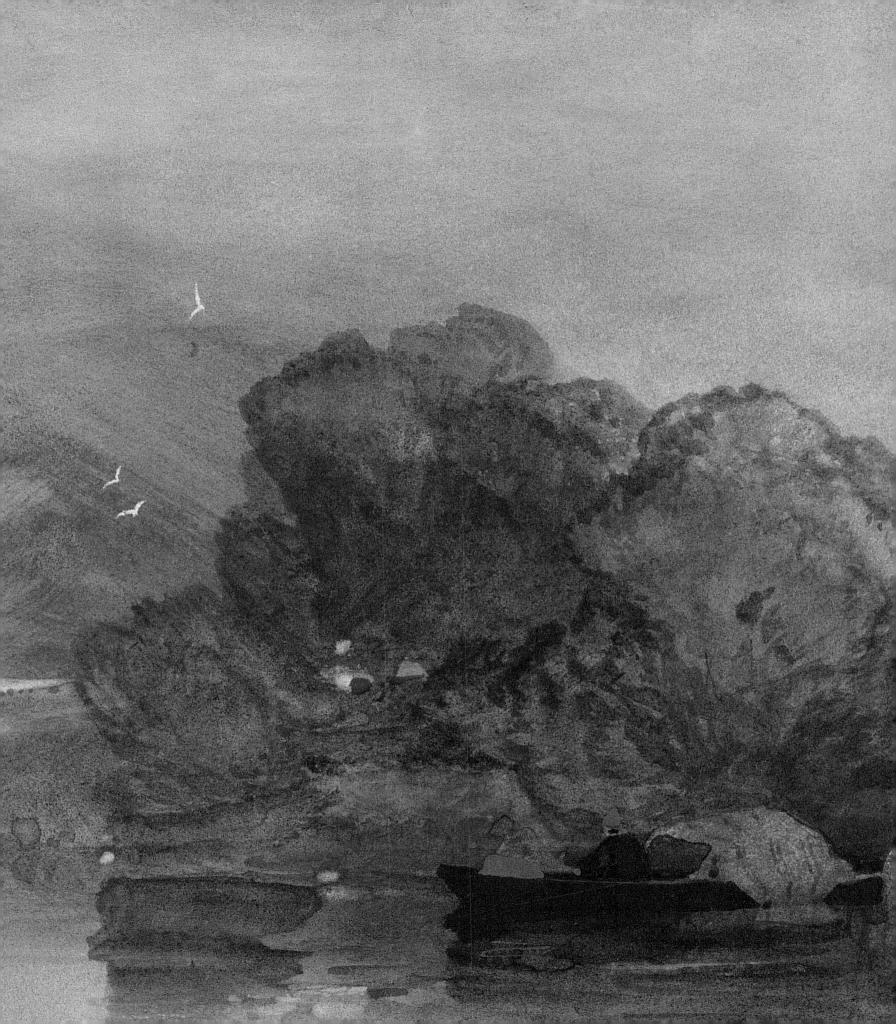

55

JOHN SELL COTMAN, 1782–1842

Gunton Park

c. 1841, inscribed *Gunton Park*, black and white chalk on grey paper, 40.6 × 33 cm (16 × 13 in.)
Bacon Inventory Number: I/B/4

Stylistically this drawing is unmistakably by John Sell Cotman, and the blue-wove wrapping paper used for it is often encountered elsewhere in his œuvre. It seems likely that Cotman made the work in 1841, on his final visit to Norfolk. Clearly, the same scene appears in a watercolour by one of the artist's sons that is discussed below (cat. 56). That work might have been made while John Sell Cotman was creating this drawing, or elaborated from it at some later date, which seems more likely.

56

JOHN JOSEPH COTMAN, 1814–78

Gunton Park

date unknown, watercolour and gouache, 36.5 × 25.4 cm (14⅜ × 10 in.)
Bacon Inventory Number: I/B/11

Opinion is divided as to who created this watercolour. The late Francis W. Hawcroft thought it to be by Cotman's second son, John Joseph Cotman, an attribution recently supported by Andrew Wyld. On the other hand, the late Russell P. Coleman and, more recently, Andrew Wilton have suggested

that the drawing was made by Miles Edmund Cotman. Certainly the image displays a straightforward naturalism that is not found in the works of John Sell Cotman.

Comparison with other drawings by both J.J. and M.E. Cotman reinforces the attribution made by Hawcroft and Wyld. In many watercolours by John Joseph Cotman we encounter depictions of complex woodland and shrubbery whose stylistic formation, painterly handling, graphic clarity, technical confidence, draughtsmanship and spatial organization are exactly like the representation of dense woodland encountered here. The Hawcroft and Wyld attribution has therefore been adopted.

John Joseph Cotman studied under his father, whom he helped with teaching duties at King's College School, London. Unhappy with this work he returned to Norwich in 1834, where he thereafter attempted to survive by teaching. Unfortunately he suffered from bouts of mental instability, which were exacerbated by alcoholism. In 1853 he exhibited at the Royal Academy, and between 1852 and 1856 he displayed eight works at the British Institution.

DAVID COX, 1783–1859

David Cox was born in Birmingham, the son of a blacksmith. Following his apprenticeship to a miniature painter he became a scene painter at the Birmingham Theatre in 1800. In 1804 he moved to London where he continued with scene-painting and made sepia drawings for dealers. During the period 1804–08 he studied with John Varley. He first exhibited at the Royal Academy in 1808, in which year he also married and set up as a drawing master. After 1805 he periodically undertook sketching tours, the most important of which were of Wales, Devonshire, Yorkshire, Derbyshire, Kent, Lancashire, Belgium, Holland and France. He exhibited with the Associated Artists in Watercolour between 1809 and 1812, and thereafter with the Society of Painters in Water Colour, of which group he became a full Member when it was reconstituted in 1820. In 1814 he became the drawing master at the Military College in Farnham, and then moved to Hereford where he taught in various schools. In 1841 he returned to Birmingham where he lived until his death.

57
DAVID COX, 1783–1859

A Gipsy Encampment
c. 1808, watercolour, 16.5 × 30.7 cm (6½ × 12⅛ in.)
Bacon Inventory Number: II/A/27

In 1808 Cox married, and soon afterwards moved into a small cottage on the edge of Dulwich Common, very near to Dulwich College (and thus not far from the site of the future Dulwich Picture Gallery). According to Cox's first biographer, at the time the common was "a lonely and rather wild spot, much frequented by gypsies, who hovered about the woods belonging to Dulwich College, which then fringed the common in unpruned luxuriance. [Cox] made many studies on the common of gypsies, their donkies and encampments, and these served him in good stead as 'incidents' in his drawings in later life" (Solly 1873, p. 21).

The degree of characterization and detailing in this watercolour, plus the fact that its landscape background is fully elaborated, suggests that it may have been the work entitled Gipsies, from Nature that Cox exhibited at the Royal Academy in 1808 (no. 457); if that was not the case, the present watercolour surely dates from around the same time. Another portrayal of gypsies exists on the verso.

58

DAVID COX, 1783–1859

Pembroke Castle

c. 1810, pencil and watercolour on laid paper with stopping-out, 44.9 × 60.3 cm (17⅝ × 23¾ in.)

Bacon Inventory Number: I/C/14

This watercolour shows the influence of John Varley, both in expressive and technical terms. Pembroke Castle was begun in the 1090s but mainly dates from about 130 years later. Here we view it near the end of day, a time that seems appropriate to a portrayal of a ruin. The complete absence of any figures makes the scene rather static, but that lack of animation was surely intentional, for it enhances the forlorn look of the medieval pile.

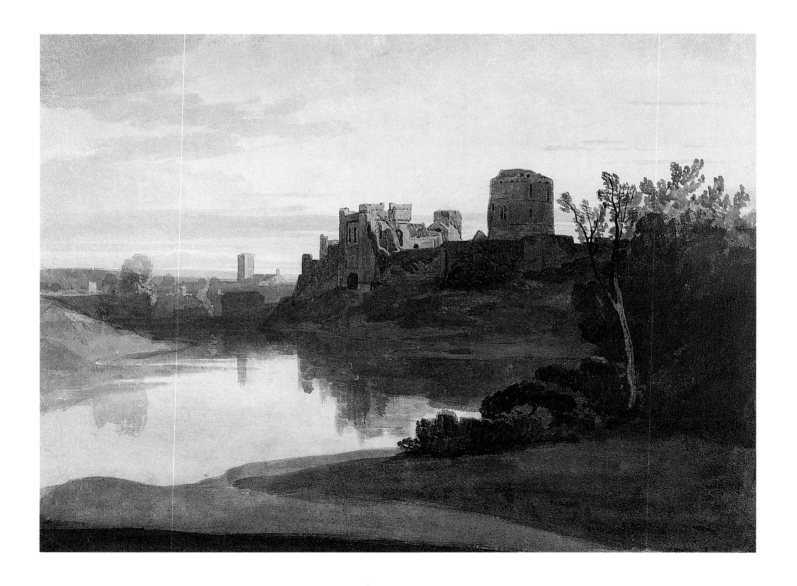

59

DAVID COX, 1783–1859

Goodrich Castle
c. 1815, watercolour, 17.7 × 24.1 cm (7 × 9½ in.)
Bacon Inventory Number: II/A/22

Goodrich Castle, near Ross-on-Wye, Herefordshire, dates from the twelfth and thirteenth centuries, and here we view it along the River Wye from upriver. Cox might well have visited the spot on his way up to Hereford in 1815. Because the flat washes used to depict the ruin and its setting are also encountered in Cox's watercolours dating from around 1815, it seems likely that he created this drawing at that time as well.

Cox was one of the earliest subscribers to the 'Liber Studiorum' set of engravings by Turner, and therefore must undoubtedly have been aware of plate 48 in that series. This is the print entitled *River Wye*, which depicts Chepstow Castle further down the same river from an angle similar to the one adopted here (although it represents the castle standing out against the sky, rather than placed below a distant skyline). Perhaps Cox elaborated this watercolour with that earlier representation in mind.

60

DAVID COX, 1783–1859

Cattle Watering in a Wooded River
1830s?, black chalk and watercolour on two sheets of laid paper, 19.6 × 43.1 cm (7¾ × 17 in.)
Bacon Inventory Number: I/C/4

After working through the influence of Varley, Cox went on to develop a formally loose, expressive style that can be seen at a fairly advanced stage of evolution in this watercolour. An anonymous annotation on a mount once used for the drawing suggested that the image is a representation of the River Wharfe at Bolton Abbey, Yorkshire, and that notion seems topographically plausible. As Peter Bower has discerned, the two sheets of paper constituting the image both originally belonged in a sketchbook; a section of paper running down the inner spine of the book was lost when the pages were detached, which is why there is a slight pictorial mismatch where the two sheets were subsequently laid down adjacently.

Peter de Wint, 1784–1849

De Wint was born to a Dutch–American father and a Scottish mother in Stone, Staffordshire. He first studied art in Stafford. In 1802 he became apprenticed to the engraver John Raphael Smith; a fellow pupil was the future historical painter William Hilton, whose sister de Wint married in 1810. After moving to London de Wint took lessons from John Varley, through whom he met Dr Thomas Monro, who in turn introduced him to the work of Girtin. In 1807, two years before he enrolled at the Royal Academy Schools, de Wint made his debut in a Royal Academy Annual Exhibition. He was elected an Associate Member of the Society of Painters in Water Colours in 1810, and a full Member the following year. Throughout his career de Wint supported himself by selling watercolours to a wide clientele. He also took pupils (especially from well-off families outside London), and taught them during the summer months. Although de Wint visited Normandy in 1828, all his other sketching tours were in England and Wales. Following his marriage to Hilton's sister, who came from Lincoln, in 1814 de Wint bought a house in the city and thereafter maintained homes both there and in London, where he died.

During his career de Wint exhibited 326 works but as he neither dated (nor signed) any of his watercolours it is impossible to establish their time of creation and thus their chronology. His landscapes are characterized by their breadth and freedom of handling, as well as by their increasingly rich colouring and exploration of chance watercolour effects. Often he used a fairly rough watercolour paper, exploiting its coarse grain to break up his washes and thereby create a sense of sparkle. All of these characteristics are well represented in watercolours by him in the Bacon collection.

61

PETER DE WINT, 1784–1849

Lincoln from the River, Sunset
c. 1816, watercolour on laid paper, 31.8 × 49 cm (12½ × 19¼ in.)
Bacon Inventory Number: III/13

Technically this watercolour shows de Wint at his most fluent, for clearly it was made with just five or six watercolour washes. Initially the painter must have covered the entire sheet with a light grey colour and, while it was still wet, brushed a soft blue across the lower part, some yellow above it, and a narrow band of pale crimson across the centre. When all these colours had dried he next used a single khaki green to denote the mass of land, with a darker tone of the same colour subsequently deepening it in places. A grey colour was later added for the depiction of the cathedral and town, as well as for the reflections at the lower left. Just a few touches of burnt sienna then supplied some rooftops on the left. Finally a dark brown wash provided all the trees across the centre. By such economical means de Wint created one of his most evocative images.

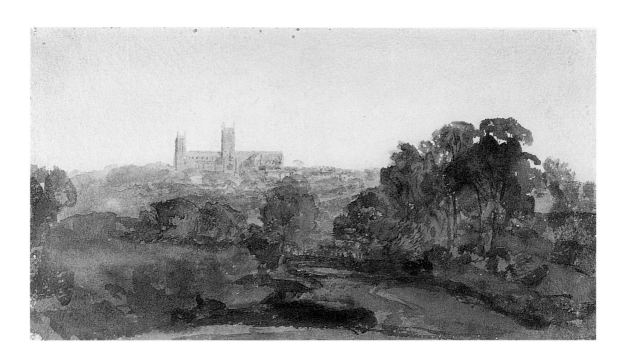

62

PETER DE WINT, 1784–1849

Lincoln from the South
1820s?, watercolour, 14.6 × 25.4 cm (5¾ × 10 in.)
Bacon Inventory Number: I/D/44

De Wint's ability to work wet-in-wet became central to his creation of watercolours. In the hands of a less intelligent painter such a method can easily result in messy diffusions and muddy colours, but quite evidently de Wint was in full control of the process when he made this drawing. By means of it the entire scene is charged with life and energy, as pinks, greens, umbers, crimsons and blues all flow around or into each other to represent the soft light of an early morning in high summer.

63

PETER DE WINT, 1784–1849

Trees by the River, near Lowther
c. 1839, watercolour, 45 × 60.9 cm (17¾ × 24 in.)
Bacon Inventory Number: I/D/32

De Wint frequently stayed with the 2nd Earl of Lonsdale at Lowther Castle in Cumbria, and he is thought to have been painting there in 1839, in which year he could have made the present water-colour. Given the proximity of the castle to the River Lowther it seems likely that we are looking at that waterway here, while the colouring of the foliage suggests that the landscape depicted might have been viewed in autumn. De Wint's spontaneous and expressive brushwork, his use of fairly rich colours (the intensity of which he might have developed from the influence of Turner) and his employment of a wet-in-wet painting technique, invests the entire scene with freshness and vitality.

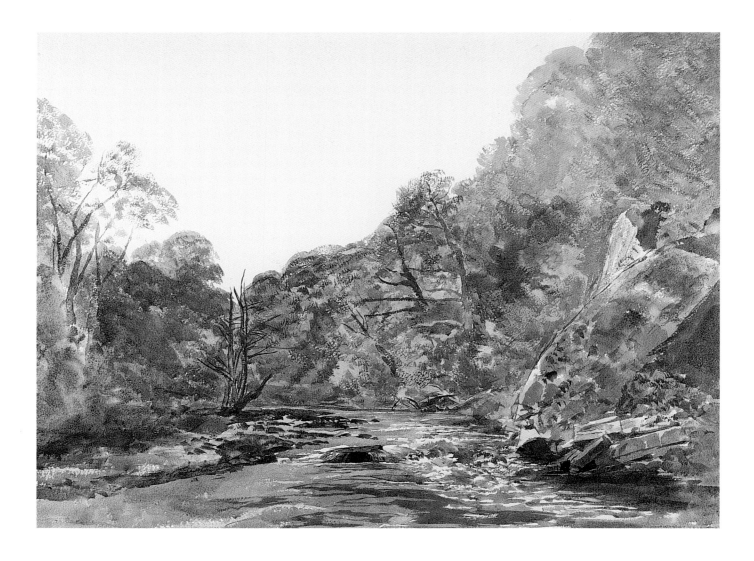

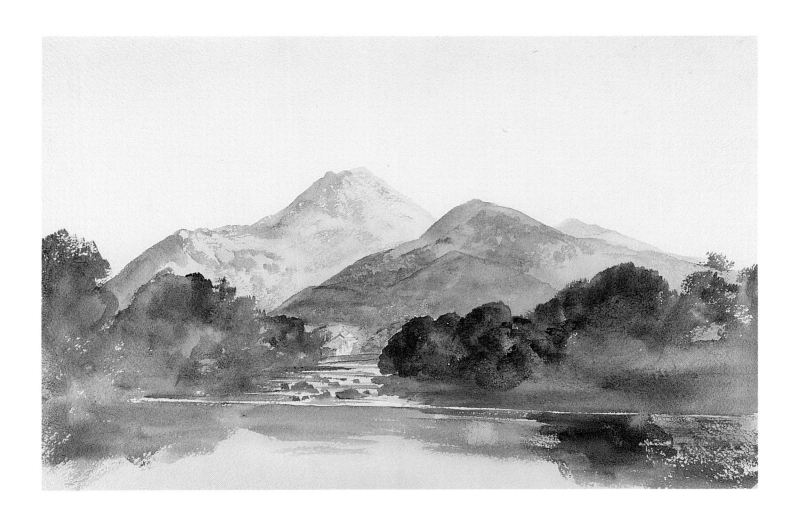

64

PETER DE WINT, 1784–1849

A Welsh Landscape with a River flowing into a Lake
1840s?, watercolour, 30.4 × 45.7 cm (12 × 18 in.)
Bacon Inventory Number: I/D/37

The brushwork deployed throughout this watercolour manifests a control and delicacy that are more usually associated with Oriental painting and calligraphy. A few simple washes evidently laid the groundwork, and then further colours were added to those underpaintings while wet in order to create colouristic variety and expressive effect. This method of finding what one wishes to express from the very act of painting itself (rather than through the realization of preconceived pictorial ideas) is what makes de Wint such an essentially forward-looking artist.

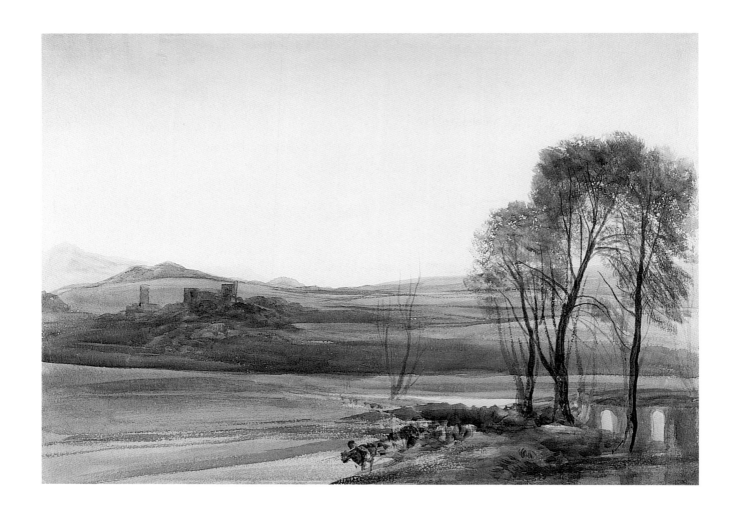

65

PETER DE WINT, 1784–1849

Clee Hills, Shropshire
c. 1845, watercolour, 38.1 × 52.7 cm (15 × 20¾ in.)
Bacon Inventory Number: I/D/28

This is one of the most sensuously painted watercolours de Wint ever created. Damp washes were first laid across the sheet to depict the distant hills. Knowing that slightly less liquid pigment would not sink down into the deepest levels of the support, de Wint then dragged such thickened paint across the grainy surface in order to allow the white paper to shine through and thereby add sparkle to both the foreground and to the trees on the right. The introduction of a small diffusion of red below the skyline to the centre-right vividly communicates the warmth of the low sun, as do the yellow-greens distributed across the foliage nearby. Again de Wint's draughtsmanship is almost Oriental in its economy, with the cattle, tree forms, reflections on the River Teme and distant buildings being indicated with intensely spare gestures.

LOUIS THOMAS FRANCIA, 1772–1839

Francia was born in Calais but moved to England in 1795, in which year he also exhibited at the Royal Academy. Soon afterwards he met Girtin at Dr Monro's 'Academy'. In 1799, along with Robert Ker Porter, he and Girtin founded the sketching club known as 'The Brothers', for which body the Frenchman acted as Secretary. After 1805 he taught drawing privately in Kensington. He was appointed the Painter in Watercolours to the Duchess of York, but failed to be elected an Associate Royal Academician in 1816, and in the following year he returned to Calais where he lived until his death. Francia's outstanding pupil in the French port was Richard Parkes Bonington, and some of the latter's initial mature works clearly demonstrate his influence. Francia himself was influenced both by Girtin and by J.S. Cotman, although for the most part he lacks the originality of either of those artists.

66

LOUIS THOMAS FRANCIA, 1772–1839

A Dismasted Brig Approaching a Harbour
c. 1818, brown wash on grey paper, 10.4 × 18 cm (4⅛ × 7⅛ in.)
Bacon Inventory Number: I/F/19

As the brig represented in this tiny drawing has lost both her topmasts and all of her yards (the cross-spars from which the sails were suspended), it is difficult to imagine how she could gain the harbour without assistance. Certainly the bare masts on the far side of the pier do not suggest that the boats to which they belong will be able to come to her aid.

We see Francia at his most inventive and expressive in this drawing, which packs a punch out of all proportion to its size. That impact owes much to the artist's understanding of the flow of energy in the sea, and to the clever way he has communicated the imbalances of wave motion. By dragging his brush across a deeply textured paper he obtained a high degree of speckling from the water-colour, which further enhances the sense of movement in the scene.

67

LOUIS THOMAS FRANCIA, 1772–1839

Calais Beach
signed and dated 1820 at lower centre, watercolour with touches of white gouache, 30.4 × 46.6 cm (12 × 18⅜ in.)
Bacon Inventory Number: III/9

This expansive view was made not long after Francia's return to his home town, and it is the type of work that would exert an enormous influence upon Bonington, whom he had adopted as an occasional student early in 1817. Francia subtly strengthened the composition by means of the diagonal line running from the lower left up to the right, along the rope, small boat, group of mussel-gatherers and beached, dismasted fishing boat, to the end of the lengthy quay beyond Fort Rouge on the horizon; this line is balanced by the edge of the beach running up to Calais in the opposite direction. The representation of the undulating sands, and of the objects littering them, testify to the artist's observational acuity.

RICHARD PARKES BONINGTON, 1802–1828

Bonington was born near Nottingham, the son of a drawing master, portrait painter and sometime Governor of Nottingham Gaol. He probably received most of his formal schooling from his mother, who was a teacher. Following the collapse of the Nottingham lace industry at the end of the Napoleonic Wars, around the end of 1817 the Bonington family moved to Calais where Bonington's father set up in the lace business; later the family resettled in Paris. While in Calais, Bonington studied with Louis Thomas Francia, through whom he absorbed the influence of Girtin.

In Paris Bonington then studied at the Ecole des Beaux-Arts, where he worked in the studio of Baron Gros; he also became friendly with Delacroix whom he met in the Louvre. In 1821 Bonington took two terms away from his studies in Paris in order to explore Normandy. In 1824 he first exhibited at the Paris Salon, where his works created a sensation, and in the following year he returned to England before possibly touring Scotland. He made his debut at the Royal Academy in 1826, and in that same year visited Venice. However, by this time he was developing consumption, and he died of the disease in London, to which city he had returned in order to seek a cure for the malady.

Bonington's work is distinguished by its romanticism, its vivacious characterization of people and places, its painterly bravura, freshness of colouring and compositional inventiveness. Despite his short life, Bonington had a huge influence on other artists in France and Britain. Indeed, he proved a seminal figure in the development of Romantic painting, both in his landscapes and marine pictures, and in his historical genre scenes – in Britain alone the painters who came under his spell included Turner, David Cox, William Callow, the Fieldings, David Roberts, Thomas Stothard, James Holland and his own pupil, Thomas Shotter Boys, while in France Delacroix wrote of him: "I could never weary of admiring his marvellous understanding of effects, and the facility of his execution".

68

RICHARD PARKES BONINGTON, 1802–1828

Fishing Boats in Boulogne Harbour
c. 1822, pen and dark-red ink and watercolour, 31.1 × 24.4 cm (12¼ × 9⅝ in.)
Bacon Inventory Number: I/F/48

Until now this watercolour has tentatively been attributed to Louis Thomas Francia, an uncertainty arising from the fact that the image seems stylistically atypical of the French painter. Moreover, the work has formerly been entitled 'Fishing Boats off a Village', although it seems likely on the visual evidence that the setting portrayed is Boulogne.

Andrew Wilton has suggested that the figures look very like those drawn around 1822 by the twenty-year-old Bonington, and that the watercolour might well be by the Englishman instead. This notion seems convincing, not least because the water also appears as though it was drawn by Bonington, as do the distant buildings. The drunken fisherman slumped in the nearest boat adds a witty touch.

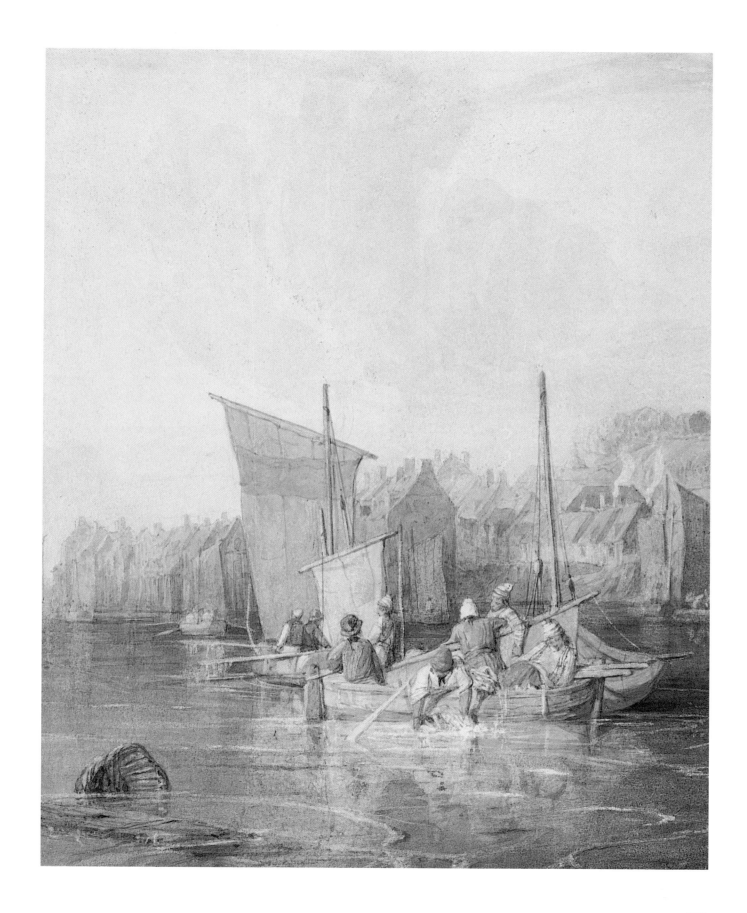

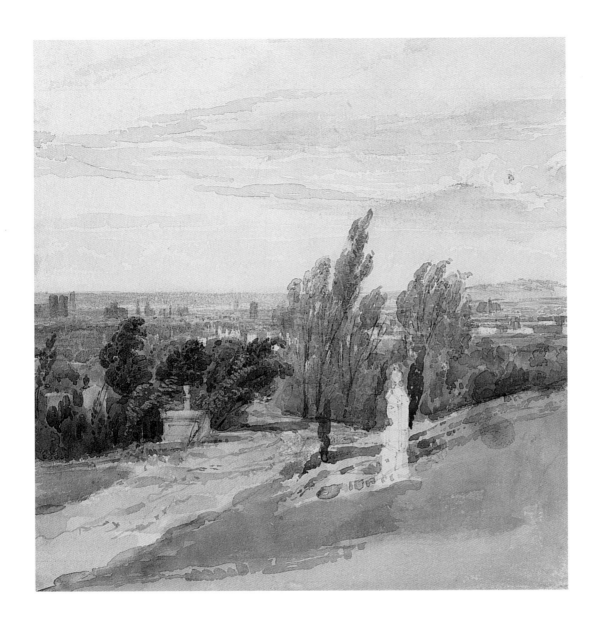

69

RICHARD PARKES BONINGTON, 1802–1828

Père Lachaise Cemetery, Paris
date unknown, pencil and watercolour, 23.4 × 21.5 cm (9¼ × 8½ in.)
Bacon Inventory Number: II/D/5

The spontaneity with which this unfinished drawing was made suggests that it might well have been created *en plein air*. The twin towers in the distance on the left are those of the cathedral of Notre-Dame, while the cursorily indicated tall building beyond and immediately to the right of them is the Dome Church of Les Invalides.

70

RICHARD PARKES BONINGTON, 1802–1828

The Sleeping Fisherman

date unknown, inscribed on the reverse *Mr. Deboix/Heroult*, pencil and watercolour, 26.9 × 30.4 cm (10⅝ × 12 in.)
Bacon Inventory Number: II/D/4

Here a smartly dressed fisherman has nodded off in the warm sunshine while his line drifts slackly in the river (or, alternatively, it has been cut). Moreover, the way that his fish bag or discarded garment is almost entirely placed within a keg in the boat suggests that the container is empty – clearly the fisherman has had no luck whatsoever in filling it with fish.

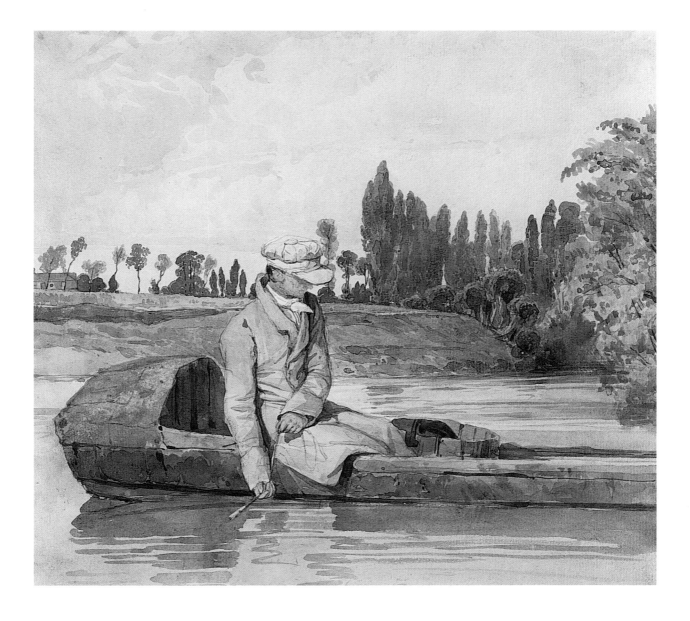

THOMAS SHOTTER BOYS, 1803–1874

Boys was born in London and trained as an engraver. Upon completing his apprenticeship in 1823 he moved to Paris where his skills were much in demand due to a dearth of practised engravers. In Paris he became friendly with Bonington, and studied with him for a time. In 1837 he returned to London where he worked as a lithographer and was instrumental in the development of chromolith-ography. In 1840 and 1841 he became respectively an Associate and then a full Member of the New Watercolour Society. By the early 1840s his career had begun to wane, and he undertook much menial work thereafter. By 1871 he was incapacitated by illness, and he died in London.

71

THOMAS SHOTTER BOYS, 1803–1874

The Oude Porte de Bruxelles at Mechelen, Belgium, with an Approaching Storm
1866?, watercolour and scratching-out, 19.4 × 27 cm (7⅝ × 10⅝ in.)
Bacon Inventory Number: II/D/13

Until now this watercolour has been entitled simply 'A French Village with an Approaching Storm' but clearly it depicts the main southern gateway of the Flemish city of Mechelen (Malines), about halfway between Brussels and Antwerp. In the distance is the fourteenth-century St Rombouts Cathedral. We look northwards in evening light.

This may be the drawing entitled 'The Oude Porte de Bruxelles at Malines' that was exhibited at the New Watercolour Society in 1866 (no. 259). Boys had previously made looser watercolours of Mechelen, one of which he exhibited at the Society of British Artists in 1831 (no. 707) and another at the New Watercolour Society of Brussels in 1832. Either of those works may have been the simi-lar view to the present design, but depicting the scene from further to the left, which was sold at Sotheby's on 19 November 1992 (lot 121, now in a private collection).

Boys was usually a rather slick architectural topographer, but here the combination of splendid architecture and a dramatic storm effect inspired him to rise above his normal level. A considerable amount of scratching away of the watercolour with a fine tool such as an etching needle was used in places to reveal the white paper beneath, and it lends an extra brilliance to the light, especially across the trees on the right.

John Frederick Lewis, RA, HRSA, 1805–1876

Lewis was the son of a London artist and engraver, F.C. Lewis, with whom he studied. As a youth he painted animals alongside Edwin Landseer. He first exhibited at the Royal Academy in 1821. Elected an Associate of the Society of Painters in Water Colours in 1827, he became a full Member of that organization five years later. He expressed himself exclusively in watercolour and gouache until the late 1850s, after which time he only used oils because of the higher prices works in that medium could attain. In 1827 he visited Switzerland and Italy, while between 1832 and 1834 he worked in Spain and Morocco. After 1837 he travelled extensively across Europe and the Middle East before settling in 1841 in Cairo, where he spent the next ten years. In 1850 the London display of one of his watercolour depictions of a harem created a sensation, and the following year he re-settled in London where he continued to live for the rest of his life. He was elected President of the Royal Watercolour Society in 1855 but resigned three years later when he turned to oil painting; he was elected an ARA in 1859, and an RA in 1865.

In his maturity Lewis specialized in genre and landscape subjects, especially with a Spanish and Oriental cast. His best works are typified by a spirited responsiveness to the characters of people and places, an expressive use of line, a rich use of colour and a meticulous feeling for detail, qualities that are evident in each of the watercolours shown here.

72

John Frederick Lewis, RA, 1805–1876

A Mountain Pass
c. 1833, pencil, pen and grey ink and watercolour heightened by white gouache on buff paper,
17.7 × 25.7 cm (7 × 10⅛ in.)
Bacon Inventory Number: 1/F/37

We can narrow down the possible geographical location of this view. The slightly pointed arch and light-filled interior of the building in the centre suggest that it may be a roofless early Gothic wayside chapel. Equally, the stone shorings and low wall of the road at the lower right are relatively sophisticated for a wild mountain area. Such details make it highly probable that the landscape depicted was one seen in Spain, where the combination of rugged geology and this kind of architecture might easily have been encountered. If we are indeed looking at a Spanish landscape, then the work could date from around 1833, when Lewis toured the Iberian peninsula.

The watercolour certainly demonstrates to the full the artist's powers as a draughtsman. Broad, fluent brushmarks both portray the complex geological structures and suggest the forces that once shattered those massive rocks. Elsewhere, finer brushstrokes define the intricacies of foliage. The red with which the solitary wayfarer is denoted fiercely sets off all the surrounding colours, while the traveller simultaneously establishes the huge scale of the landscape.

73

JOHN FREDERICK LEWIS, RA, 1805–1876

Study of a Seated Arab with Dead Game
1840s?, pencil and watercolour heightened with white gouache on buff paper, 28.5 × 44.4 cm (11¼ × 17½ in.)
Bacon Inventory Number: I/F/35

Like cat. 74, this work was probably made when Lewis was living in Cairo during the 1840s. The technical fluency of the two drawings is outstanding but the artist has avoided slickness by forcefully projecting the character of his subjects.

74

JOHN FREDERICK LEWIS, RA, 1805–1876

Study of Three Arabs
1840s?, pencil, watercolour and bodycolour, 35.5 × 50.8 cm (14 × 20 in.)
Bacon Inventory Number: I/F/43

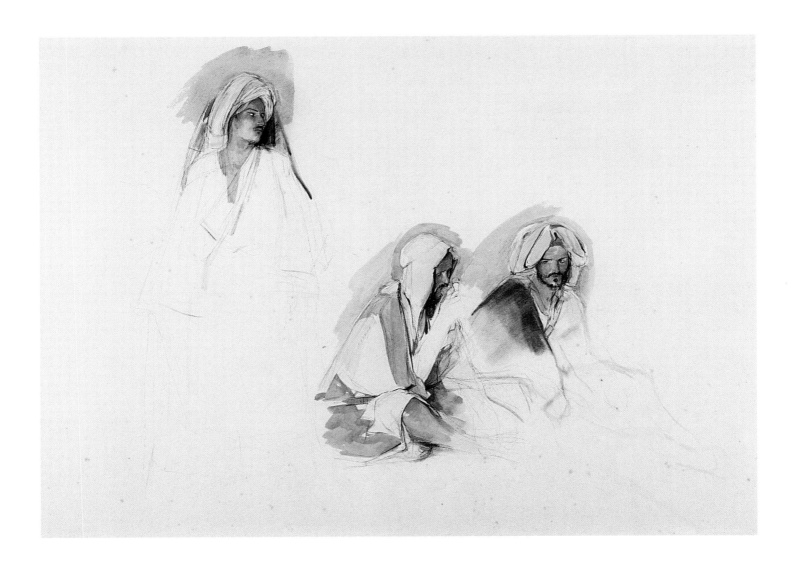

75

JOHN FREDERICK LEWIS, RA, 1805–1876

The Great Door of the El-Ghûry Mosque at Ghûriyya, Cairo
1840s, pencil and watercolour heightened with white gouache on buff paper, 52.7 × 38.1 cm (20¾ × 15 in.)
Bacon Inventory Number: I/F/44

This drawing amply demonstrates Lewis's remarkable skills as an architectural draughtsman. For many centuries the Ghûriyya district of Cairo has been one of the major commercial centres of the city, with much of Egypt's foreign trade being carried on there. The last of the Mamlûk sultans, Kansuh El-Ghûry, built the mosque depicted in the early sixteenth century.

WILLIAM JAMES MÜLLER, 1812–45

Müller was the son of the Danzig-born Curator of the Bristol Institution, an art, natural history and geological museum. For over two years in the late 1820s Müller studied with the watercolourist J.B. Pyne. Influenced by Cotman, he explored East Anglia in 1831, and subsequently travelled much further afield, in 1834–35 touring Germany, Switzerland and Italy, and in 1838–39 Greece and Egypt. In 1840 he visited northern France in connection with an engraving project, while in 1843 he travelled to Turkey as part of an archaeological expedition. This tour contributed to a decline in his health, which in turn led to his early death.

76

WILLIAM JAMES MÜLLER, 1812–45

A Barge at a Lock
date unknown, watercolour, 17.7 × 39 cm (7 × 15⅜ in.)
Bacon Inventory Number: I/D/16

The employment of a very free watercolour technique here enabled Müller to convey a powerful sense of atmosphere, while the use of a single dark wash to brush in the barge, lock gates and foliage on the right demonstrates how convincingly and economically he could represent appearances.

77

WILLIAM JAMES MÜLLER, 1812–45

On the Acropolis, Athens: The Erechtheion
c. 1838, pencil and watercolour, 42.5 × 29.2 cm (16¾ × 11½ in.)
Bacon Inventory Number: I/D/12

In the autumn of 1838 Müller spent six weeks in Athens, where he made over forty watercolours, almost thirty of which were views of the Acropolis. Here we look through a light-filled Erechtheion, the left concrete pillar of which replaced the caryatid that had been removed by Lord Elgin and later sold to the British Museum. Judging by the detailed way he drew the hair of the caryatids, Müller particularly admired that feature of the sculptures.

78

WILLIAM JAMES MÜLLER, 1812–45

The Mahmudiyya Mosque, Cairo
c. 1838, pencil and watercolour, 34.9 × 24.7 cm (13¾ × 9¾ in.)
Bacon Inventory Number: I/D/27

The Mahmudiyya Mosque stands near to the Midan Salah-al-Din or Saladin Square, Cairo, and dates from 1568. The red stripes on the houses along the street were painted in 1831 to celebrate the return of the son of the Pasha of Egypt, Ibrahim Pasha, who had conquered Syria in that year. Although the sun is fairly high in the sky, the street is curiously deserted; perhaps Müller made the drawing on a Friday, when the commercial life of Cairo would necessarily have come to a standstill.

79

WILLIAM JAMES MÜLLER, 1812–45

Xanthus from the Sands

signed and dated lower left *Xanthus from ye/Sands.* 1843/*Dec 28 WM*, pencil, watercolour and gouache,
24.1 × 56.5 cm (9½ × 22¼ in.)
Bacon Inventory Number: I/D/3

In late 1843 and early 1844 Müller spent three somewhat uncomfortable months as a member of
an archaeological expedition to the Xanthus valley in Lycia, south-west Turkey.

 In the distance of this unusually wide panorama the Taurus mountains are capped with winter
snow. The bleached timbers and footmarks approaching from afar further assist in conveying the
inhospitability of the surroundings.

80

WILLIAM JAMES MÜLLER, 1812–45

Rock Tombs, Pinara
signed and dated lower left *Rock Tombs Pinara. W.M./Novr. 16 1843.*, pencil, watercolour and gouache,
56.5 × 38.1 cm (22¼ × 15 in.)
Bacon Inventory Number: I/D/15

In mid-November 1843 Müller left Xanthus as part of a subsidiary expedition to Pinara, one of Lycia's most spectacular ancient cities. He spent nine days there, and found it particularly inspiring; as he wrote later, "Pinara, with its mountain like a giant castle pierced with thousands of loop holes … forms one of the grandest subjects for the pencil … ever seen" (letter to the *Art Union*, February 1844, p. 42). The "thousands of loop holes" were the multitudinous tombs cut into the rock face at Pinara, one of which we see here. The work shows to advantage Müller's bold draughtsmanship and spare but effective use of colour.

ARTHUR SEVERN, 1842–1931

Severn was a protégé of John Ruskin, whose niece he married in 1871. The following year he toured Italy with Ruskin and with Albert Goodwin (see opposite). He exhibited regularly at the Royal Academy between 1863 and 1893, as well as at the New Watercolour Society and in the Dudley Gallery, which was founded by his brother.

81

ARTHUR SEVERN, 1842–1931

Coniston Water looking on to the Mines

date unknown, signed lower right and inscribed lower left on drawing and mount *Coniston Water looking on to the mines*, watercolour and bodycolour on blue paper, 11.1 × 17.7 cm (4⅜ × 7 in.)

Bacon Inventory Number: II/D/39

In later years John Ruskin lived at Brantwood on Coniston Water, and Severn often stayed there. The sunset view depicted is the one seen from slightly north of the house when looking across the lake towards Coniston, with Coniston Old Man (803 m, 2633 ft) in the far distance. The mines referred to in Severn's title could have been either the slate or the copper mines that stood on the lower slopes of Coniston Old Man; they ceased production respectively in 1935 and 1942.

The image enjoys an unusual polarization of colours, with its single, flat wash of blue portraying the shadows falling across the Cumbrian hills.

ALBERT GOODWIN, 1845–1932

Goodwin was a passionate follower of Turner and, like his exemplar, he also made his debut at the Royal Academy when he was just fifteen. In the early 1860s he studied briefly with Ford Madox Brown and Arthur Hughes, and in 1872 he toured Italy with Ruskin and Arthur Severn. Thereafter he travelled widely throughout Europe, Egypt, India and the South Pacific. He was elected a full Member of the Old Watercolour Society in 1881.

82

ALBERT GOODWIN, 1845–1932

View of the Alps, Switzerland
date unknown, signed and inscribed on the reverse, watercolour, 12 × 16.8 cm (4¾ × 6⅝ in.)
Bacon Inventory Number: II/F/10

Goodwin never shook off the influence of both Turner and Whistler, and although his works are not therefore stylistically innovative, they do rank among the most evocative landscapes of the late nineteenth and early twentieth centuries, especially in watercolour. The drawing shown here is a fine example of his art.

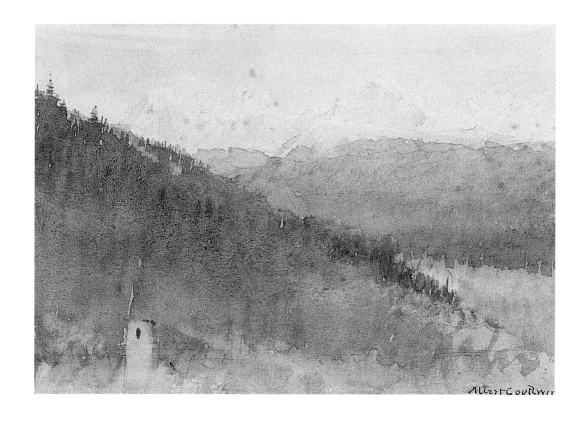

Selected Bibliography

BELL, C.F., and Girtin, Thomas, 'The Drawings and Sketches of John Robert Cozens', *Walpole Society*, vol. XXIII, 1935

BINYON, Lawrence, *John Crome and John Sell Cotman*, London 1897

BUTLIN, Martin, and Joll, Evelyn, *The Paintings of J.M.W. Turner*, Rev. Ed., New Haven and London 1984

CLIFFORD, Derek, and Clifford, Timothy, *John Crome*, London 1968

FINBERG, A.J., *A Complete Inventory of the Drawings in the Turner Bequest*, London 1909

FINBERG, A.J., *Early English Water-Colour Drawings by the Great Masters*, London 1919

GIRTIN, Thomas, and Loshak, David, *The Art of Thomas Girtin*, London 1954

GREENACRE, Francis, and Stoddard, Sheena, *W.J. Müller 1812–1845*, exhib. cat., Bristol Art Gallery, 1991

HARDIE, Martin, *Watercolour Painting in Britain*, London 1966

HAWCROFT, Francis, 'English Water-colours and Drawings in the collection of Sir Edmund Bacon, Bart.', *Old Water-Colour Society's Club*, vol. XXXVII, 1962

HAWCROFT, Francis, *Watercolours by John Robert Cozens*, exhib. cat., Manchester, Whitworth Art Gallery, 1975

HEMINGWAY, Andrew, *The Norwich School of Painters 1803–1833*, Oxford 1979

KITSON, Sidney, *The Life of John Sell Cotman*, London 1937

LE NOUËNE, P., and Haudiquet, A., *Louis Francia 1772–1839*, exhib. cat., Calais, Musée des Beaux-Arts et de la Dentelle, 1988

LEWIS, Michael, *J.F. Lewis*, Leigh-on-Sea 1978

MOORE, Andrew W., *John Sell Cotman 1782–1842*, exhib. cat., Norwich Castle Museum, 1982

MORRIS, Susan, *Thomas Girtin 1775–1802*, exhib. cat., New Haven, Yale Center for British Art, 1986

Noon, Patrick, *Richard Parkes Bonington*, exhib. cat., New Haven, Yale Center for British Art, 1991

OPPÉ, A.P., *The Water-colour Drawings of John Sell Cotman*, London 1923

OPPÉ, A.P., *Alexander and John Robert Cozens*, London, 1952

PARRIS, Leslie (ed.), *Landscape in Britain, c 1750–1850*, exhib. cat., London, Tate Gallery, 1974

POINTON, Marcia, *The Bonington Circle: English Watercolour and Anglo-French Landscape 1790–1855*, Brighton 1985

POWELL, Cecilia, *Turner's Rivers of Europe: The Rhine, Meuse and Mosel*, exhibition catalogue, Tate Gallery, London, 1991

POWELL, Cecilia, *Turner in Germany*, exhib. cat., London, Tate Gallery, 1995

RAJNAI, Miklos, and others, *John Sell Cotman 1782–1842*, exhib. cat., London, Victoria and Albert Museum, 1982

ROUNDELL, James, *Thomas Shotter Boys*, London 1974

RUSSELL, John, and Wilton, Andrew, *Turner in Switzerland*, Zurich 1976

SCRASE, David, *Drawings and Watercolours by Peter De Wint*, exhib. cat., Cambridge, Fitzwilliam Museum, 1979

SHANES, Eric, *Turner's England, 1810–1838*, London 1990

SHANES, Eric, *Turner's Watercolour Explorations*, exhib. cat., London, Tate Gallery, 1997

SHANES, Eric, *Turner: The Great Watercolours*, exhib. cat., London, Royal Academy of Arts, 2000

SLOAN, Kim, *Alexander and John Robert Cozens, The Poetry of Landscape*, New Haven and London 1986

SOLLY, N. Neal, *Memoir of the Life of David Cox*, London 1873

TAYLOR, Basil, *Joshua Cristall*, exhib. cat., London, Victoria and Albert Museum, 1975

TISDALL, John, *Joshua Cristall 1768–1847, In Search of Arcadia*, London 1996

WILDMAN, Stephen, and others, *David Cox 1783–1859*, exhib. cat., Birmingham City Art Gallery, 1983

WILLIAMS, Iolo A., 'Sir Hickman Bacon's Water-Colours', *Country Life*, 5 April 1946

WILTON, Andrew, *The Life and Art of J.M.W. Turner*, Fribourg 1979, catalogue of watercolours

WILTON, Andrew, and Lyles, Anne, *The Great Age of British Watercolours 1750–1880*, exhib. cat., London, Royal Academy of Arts, 1993

YARDLEY, Edward, 'A Margate Sketchbook Re-assembled?', *Turner Studies*, vol. 4, no. 2, 1984

YARDLEY, Edward, 'The Turner Collector: The Birket Foster Collection of Turner Watercolours', *Turner Studies*, vol. 8, no. 1, 1988

Index